Nous ne sommes pas vos ennemis
Nous voulons vous donner de vastes et d'étranges domaines
Où le mystère en fleurs s'offre à qui veut le cueillir
Il y a là des feux nouveaux des couleurs jamais vues
Milles phantasmes impondérables
Auxquels il faut donner de la réalité

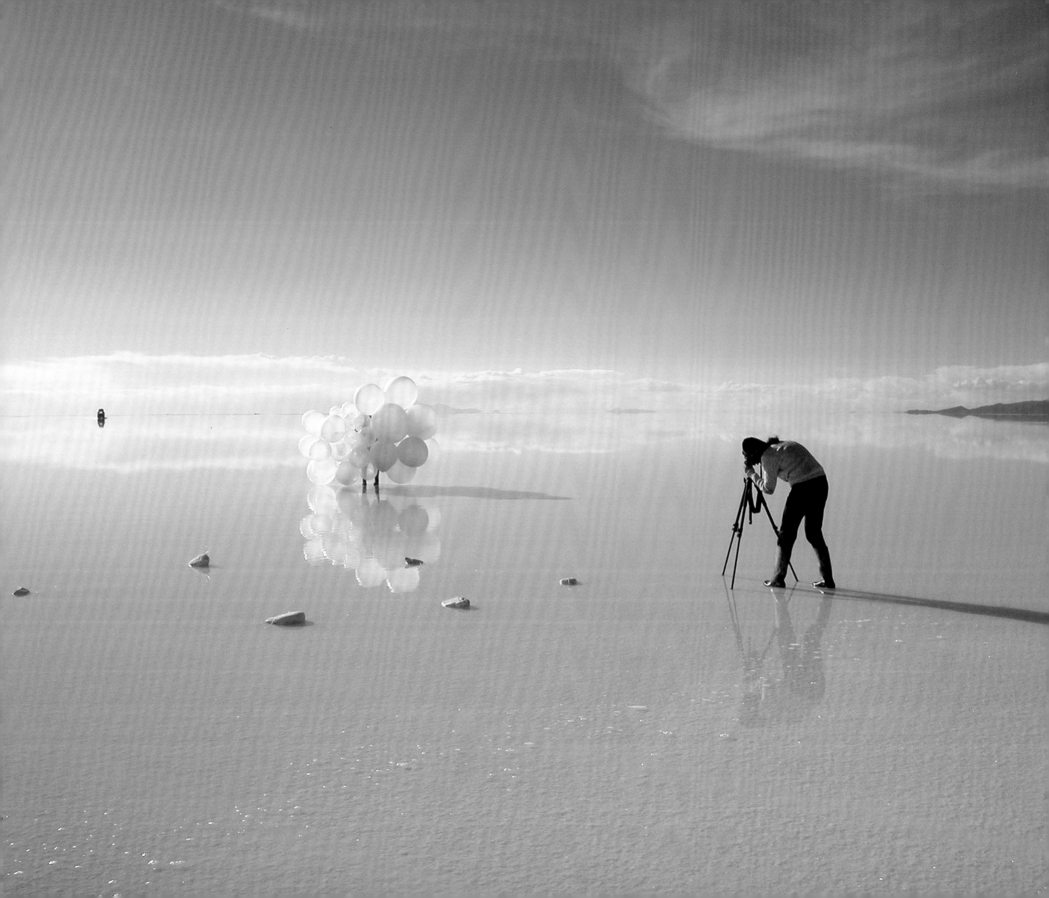

Scarlett Hooft Graafland

Soft Horizons

KEHRER

Dedicated to my father,
who gave me so much space

2007.2008

Canada
Nunavut, Igloolik

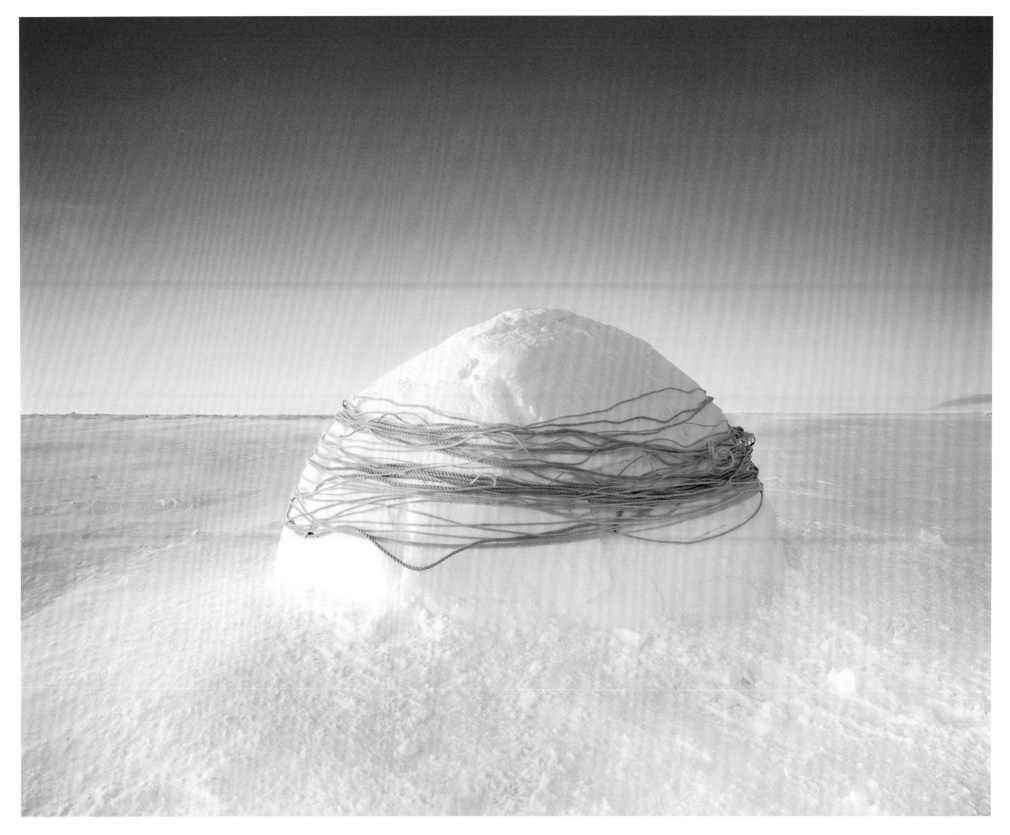

Wrapped

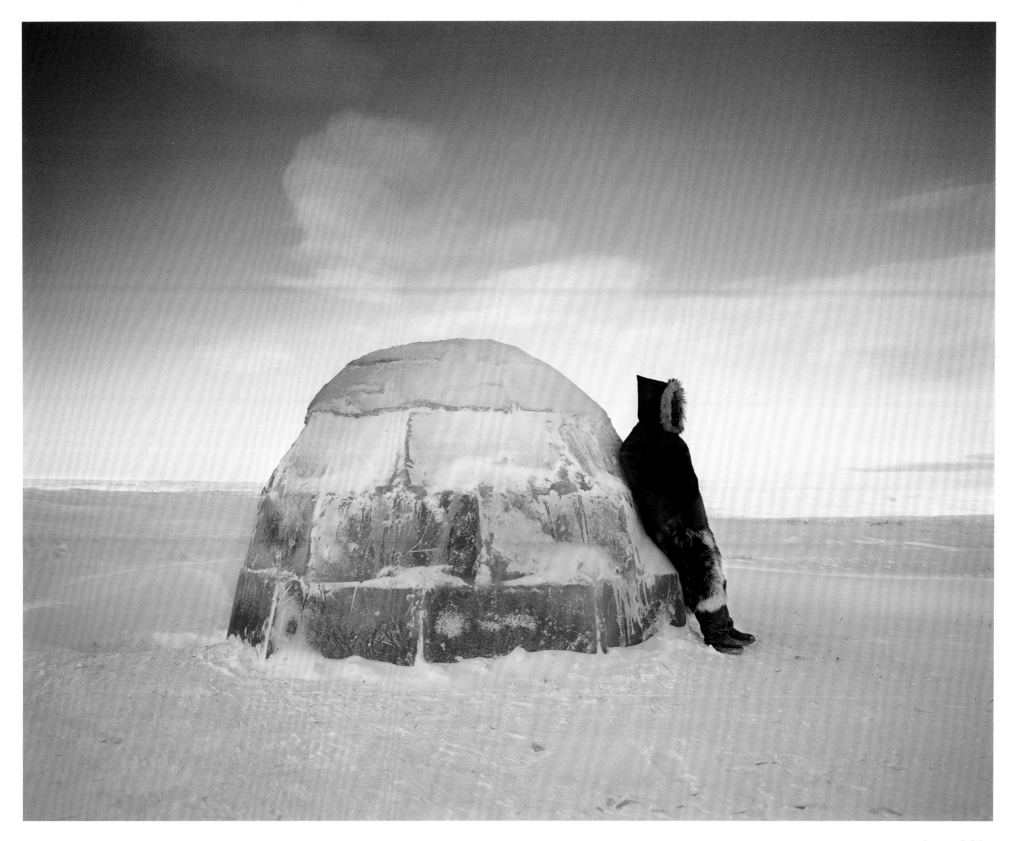

Lemonade Igloo

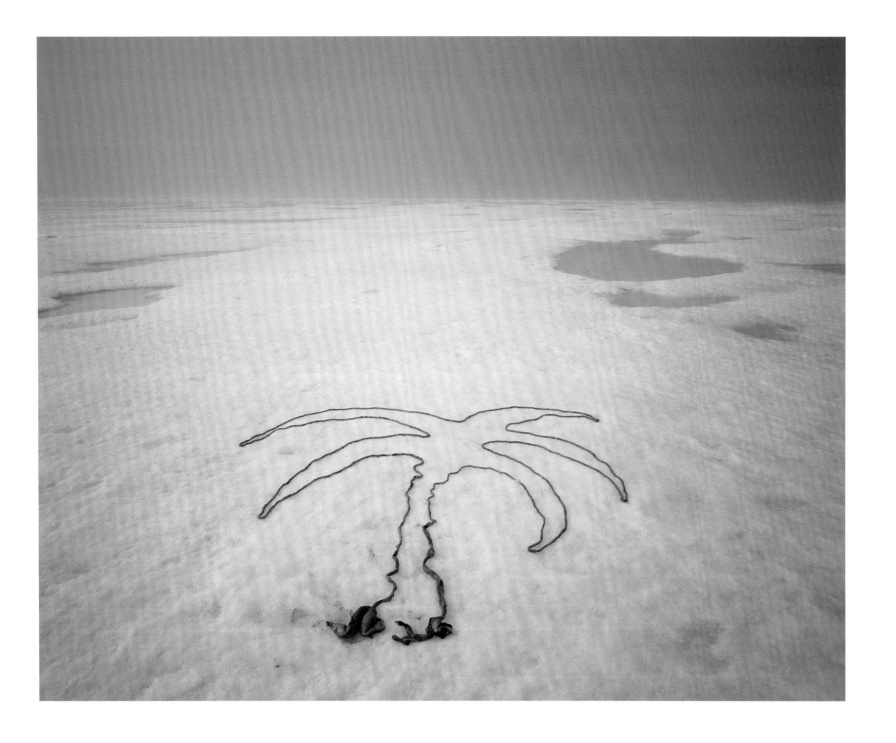

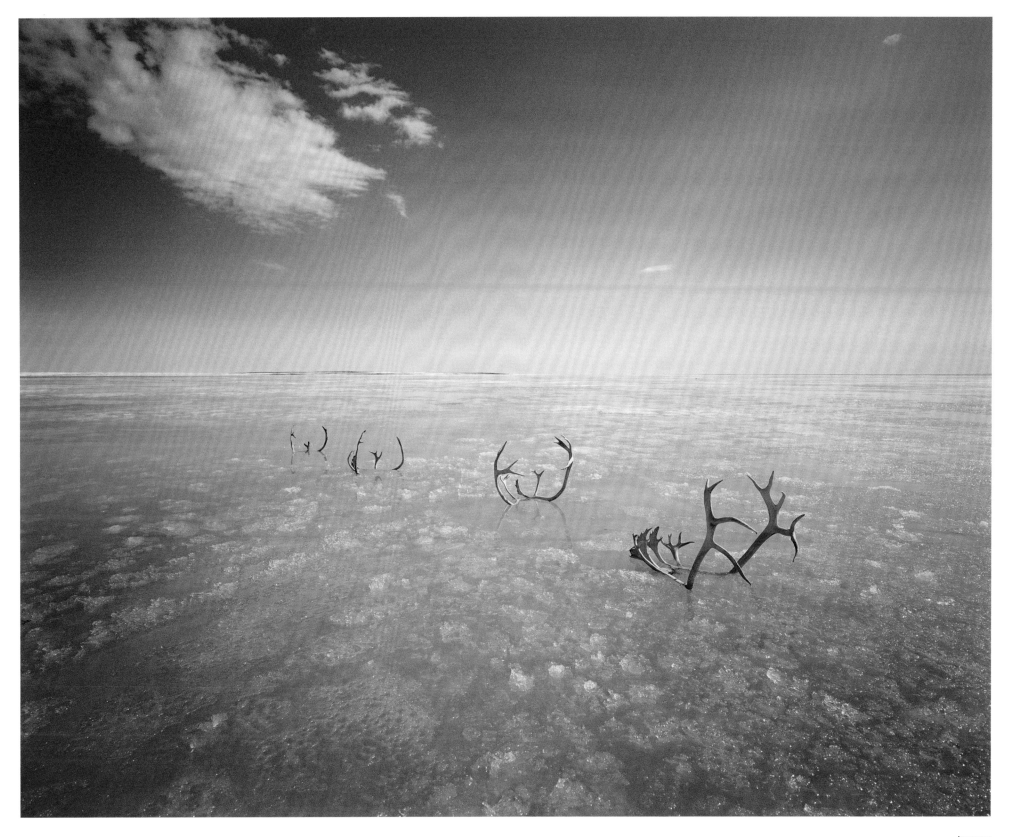

Journey

My White Night

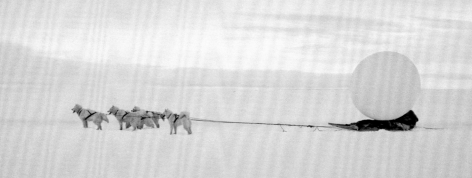

Polar Bear

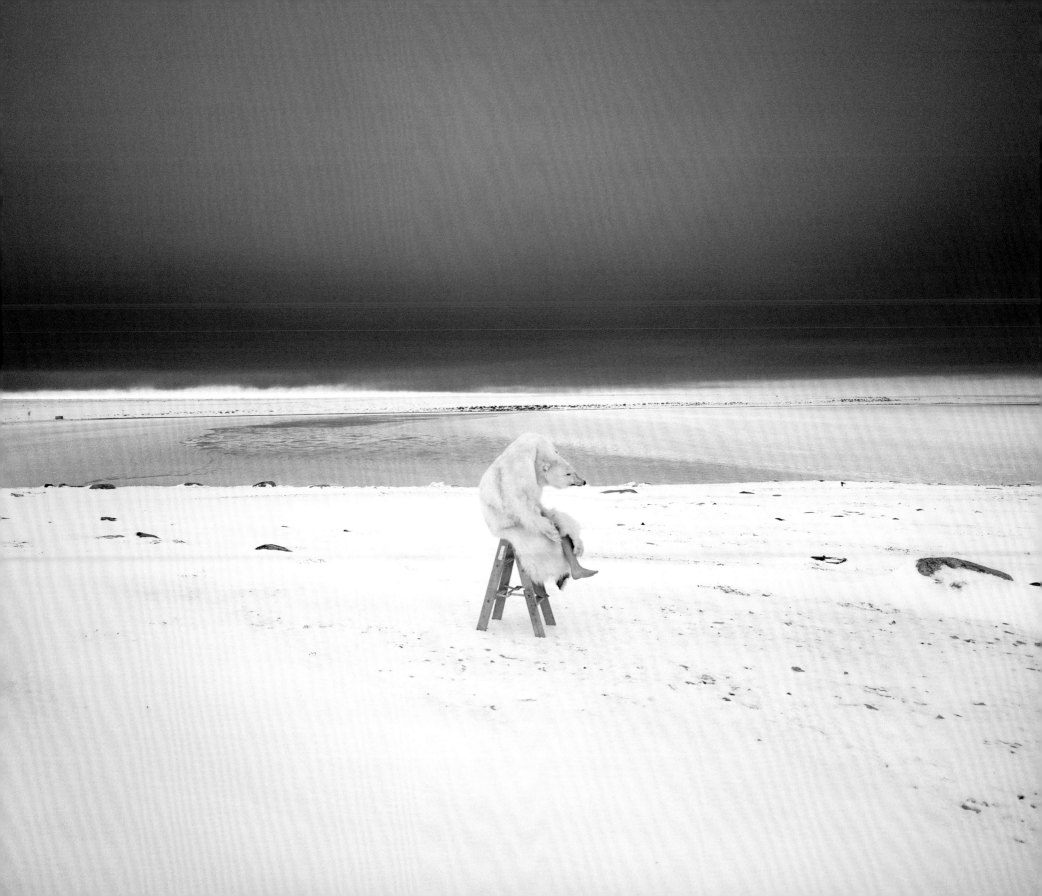

2006.2007

Bolivia
Altiplano, Salar desert

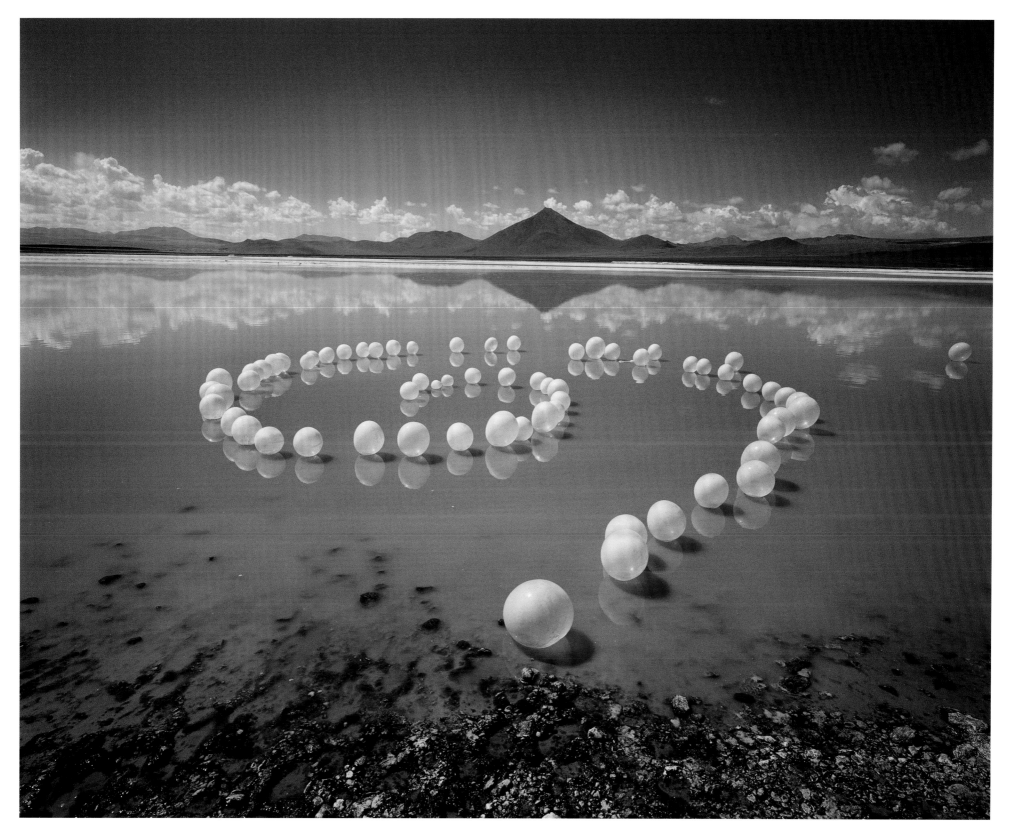

Vanishing Traces

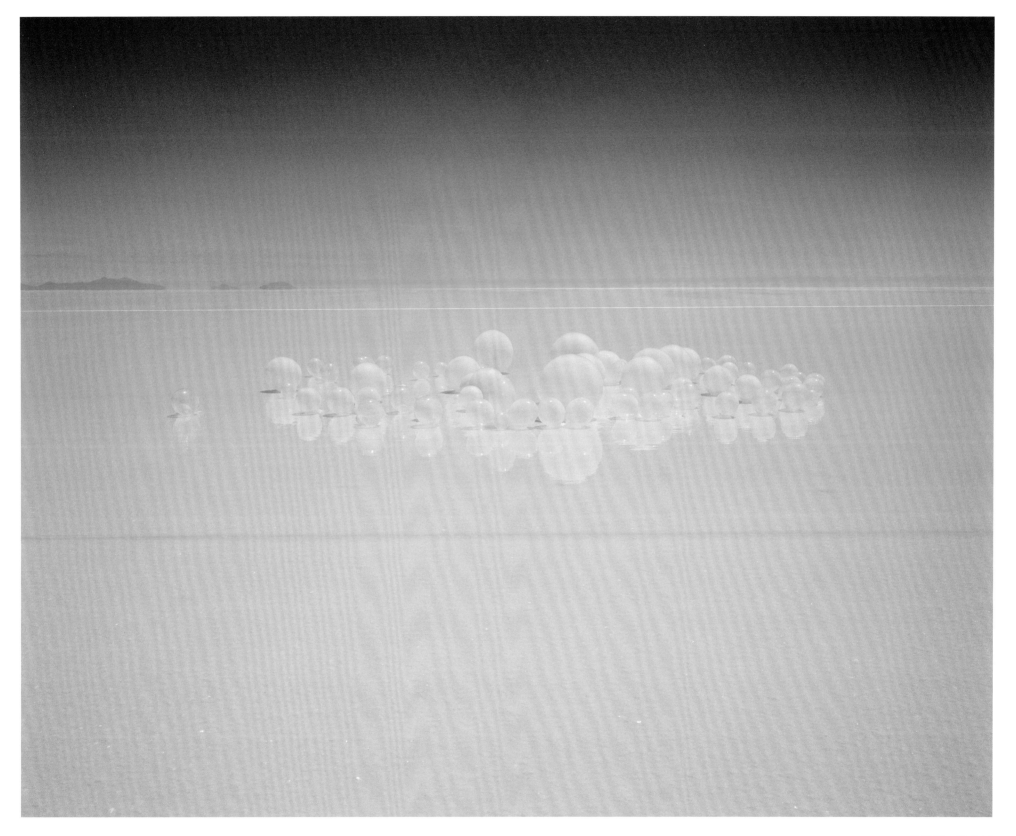

Drop your Darlings

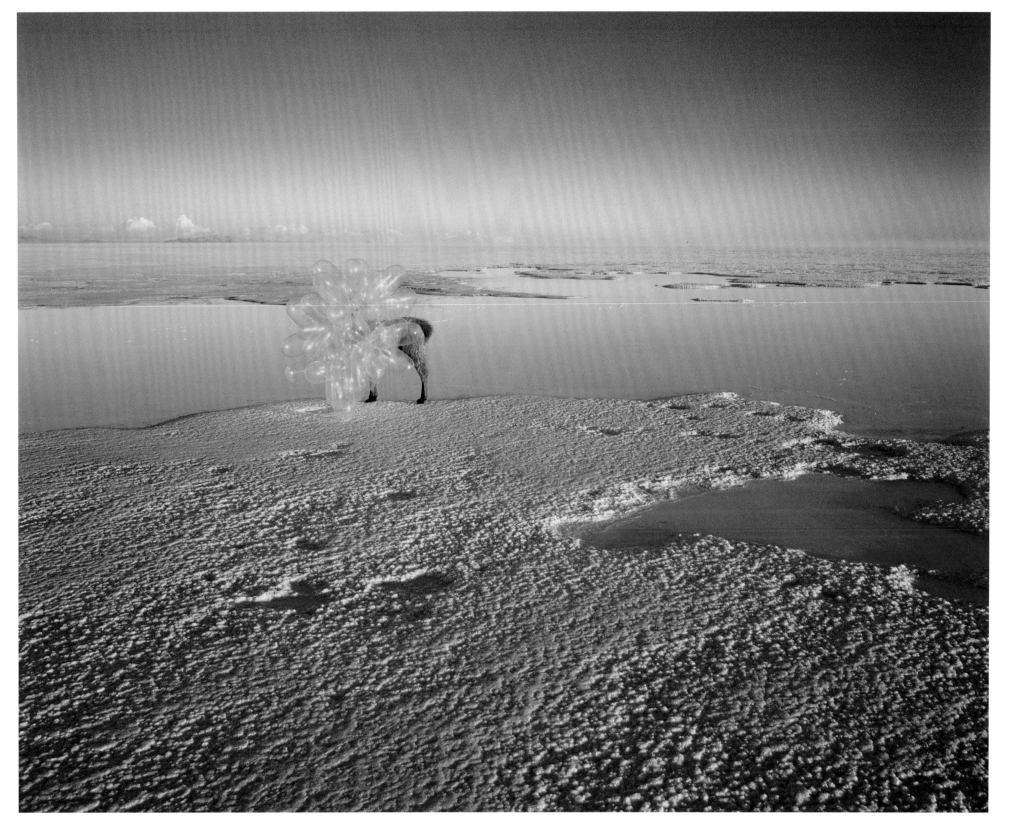

Flash

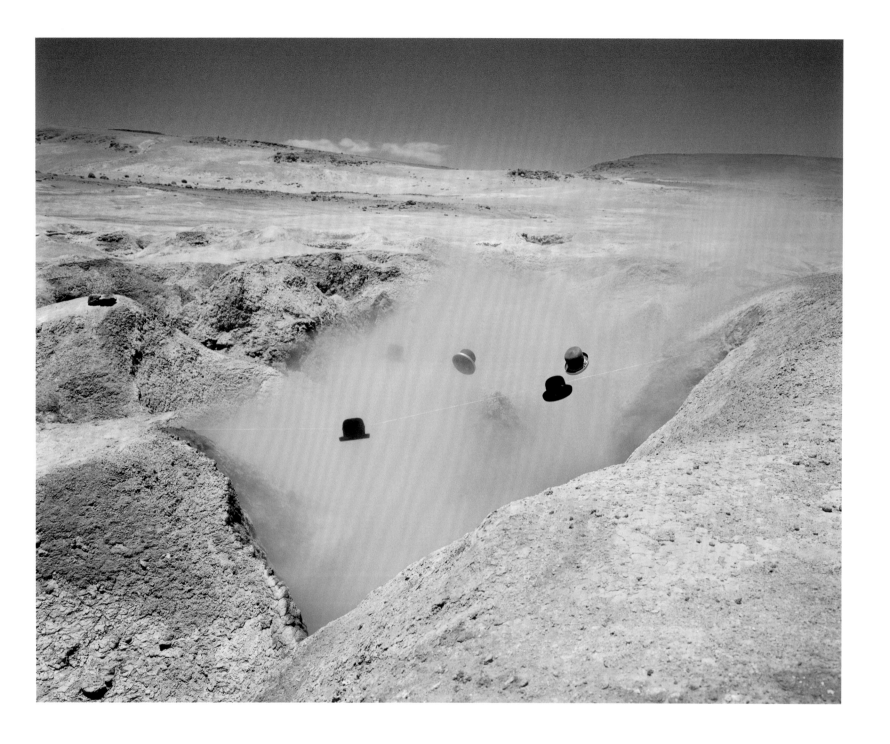

Harvest Time

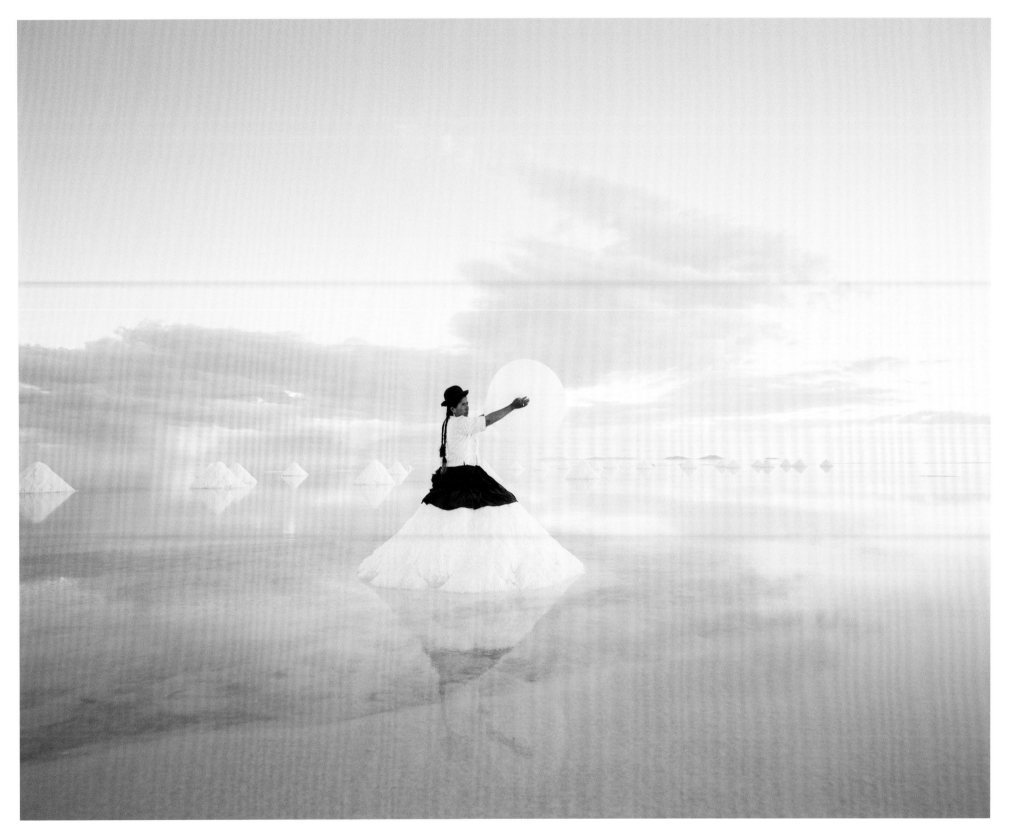

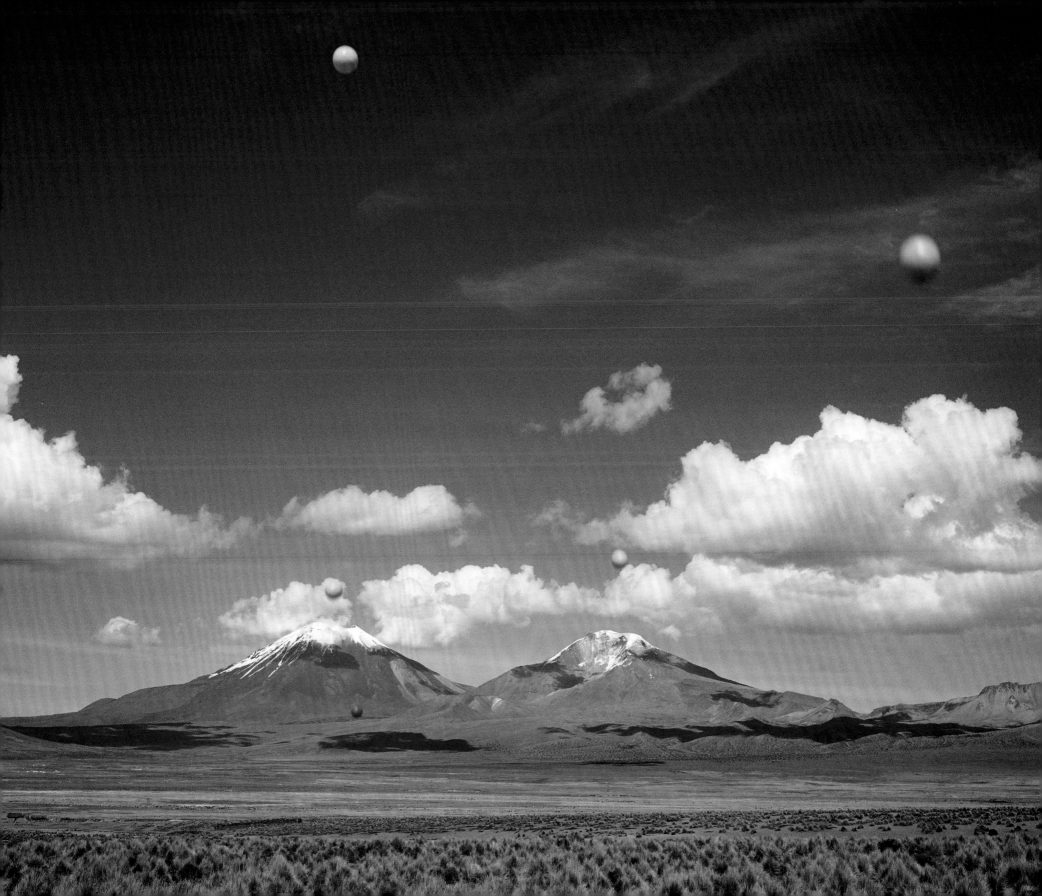

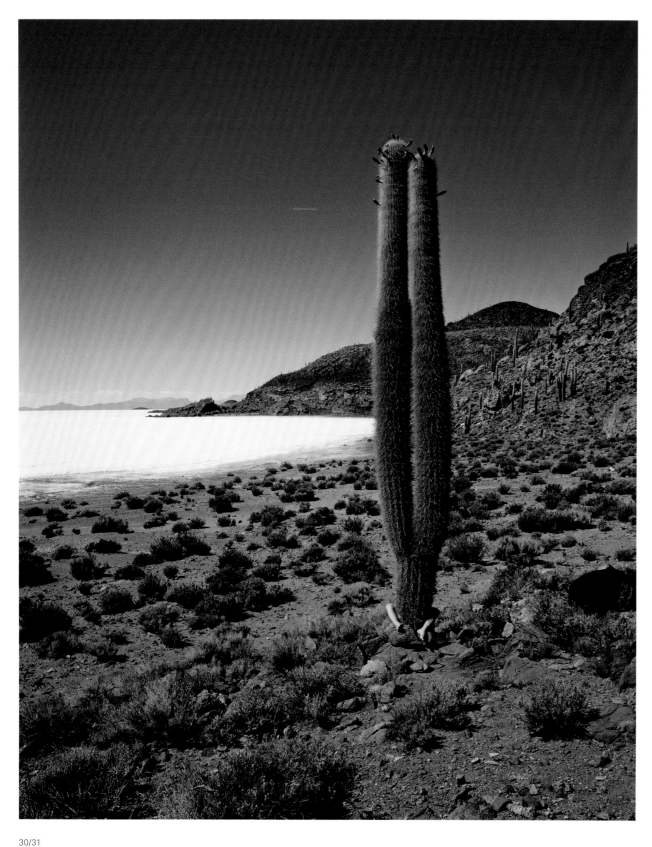

Discovery

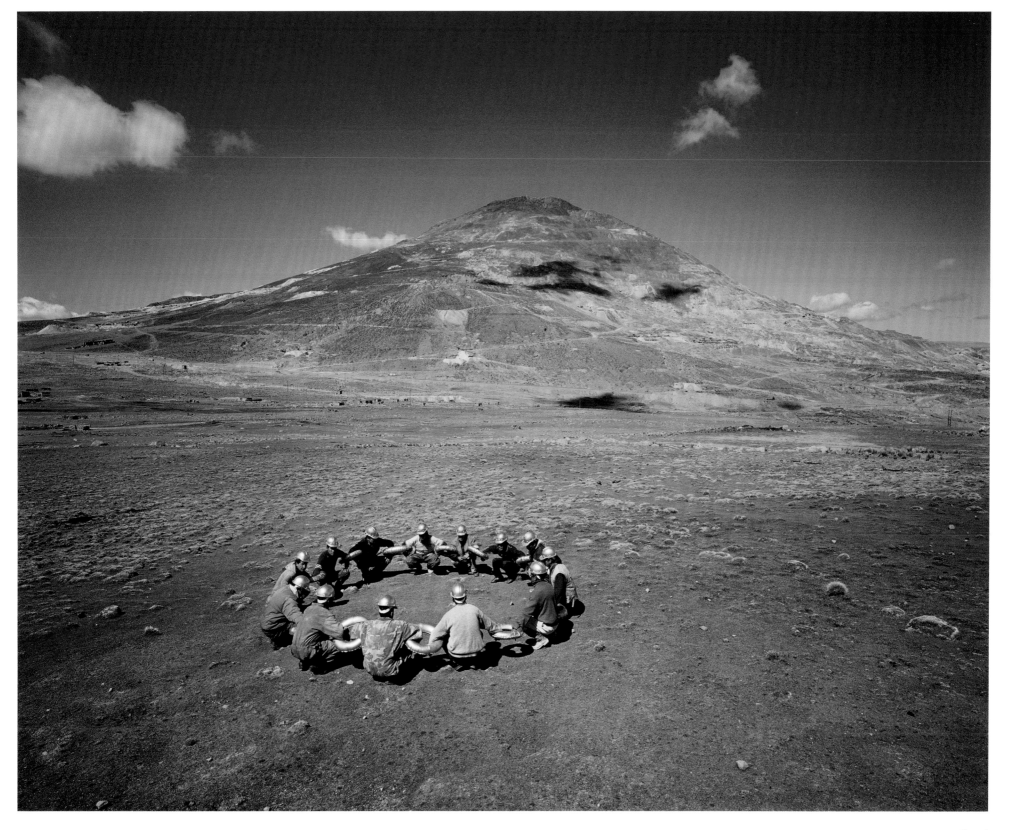

Potosi

Iceland
Reykjavik area

White

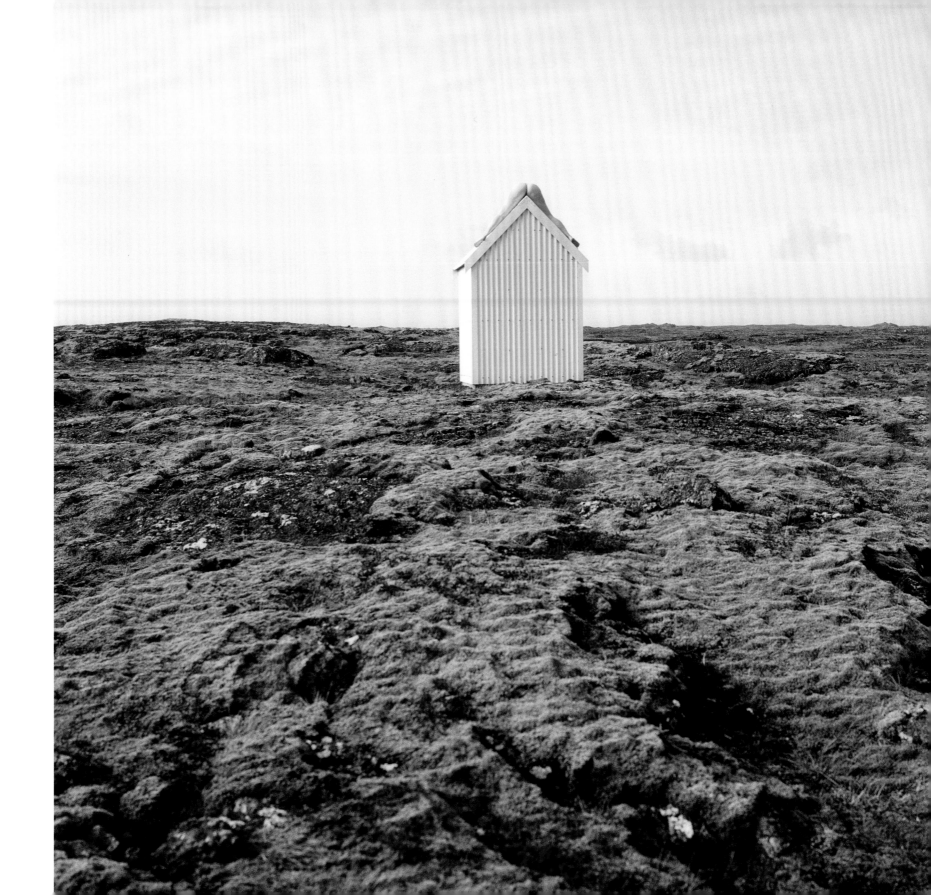

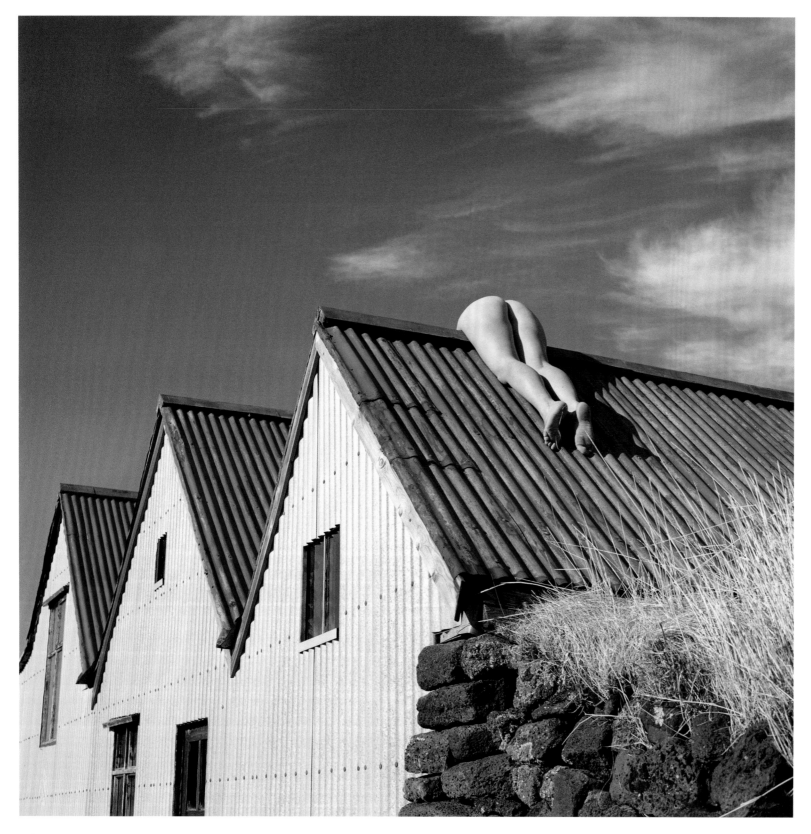

Green 2

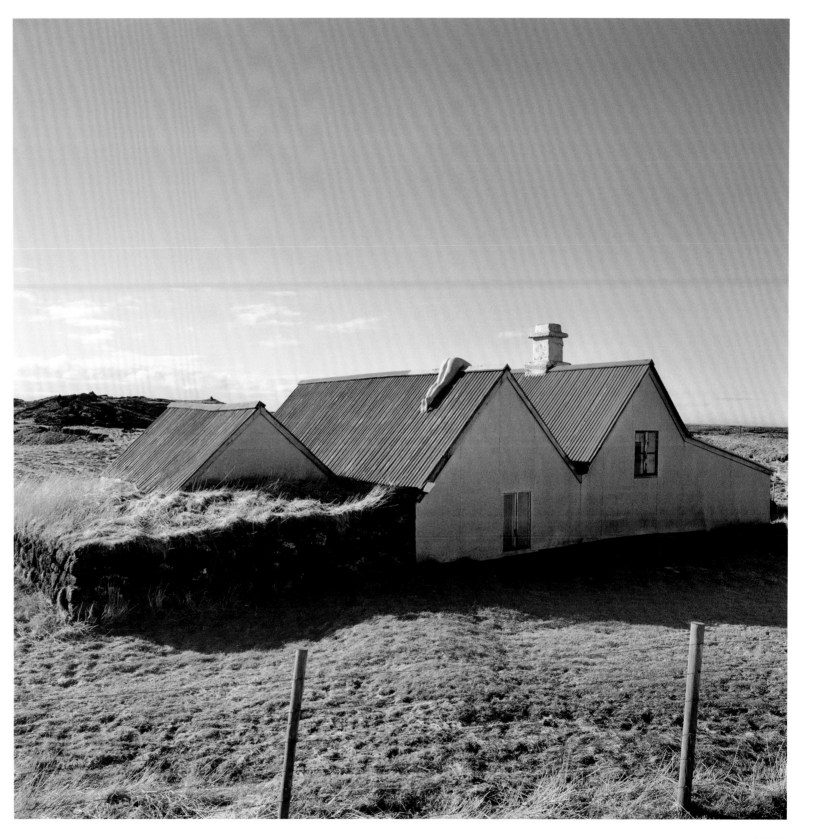

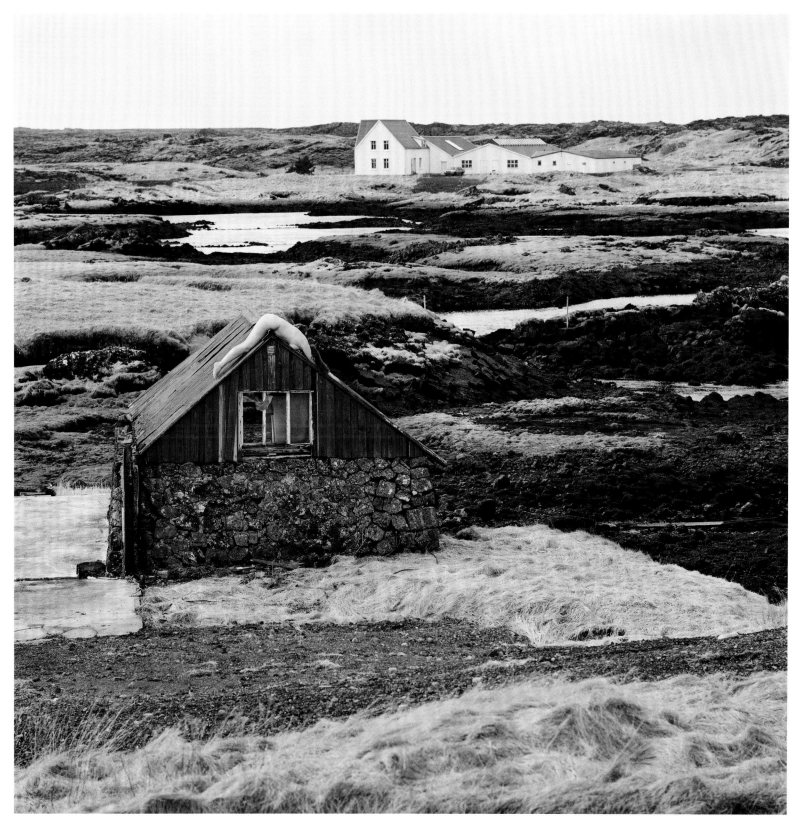

Brown

Red

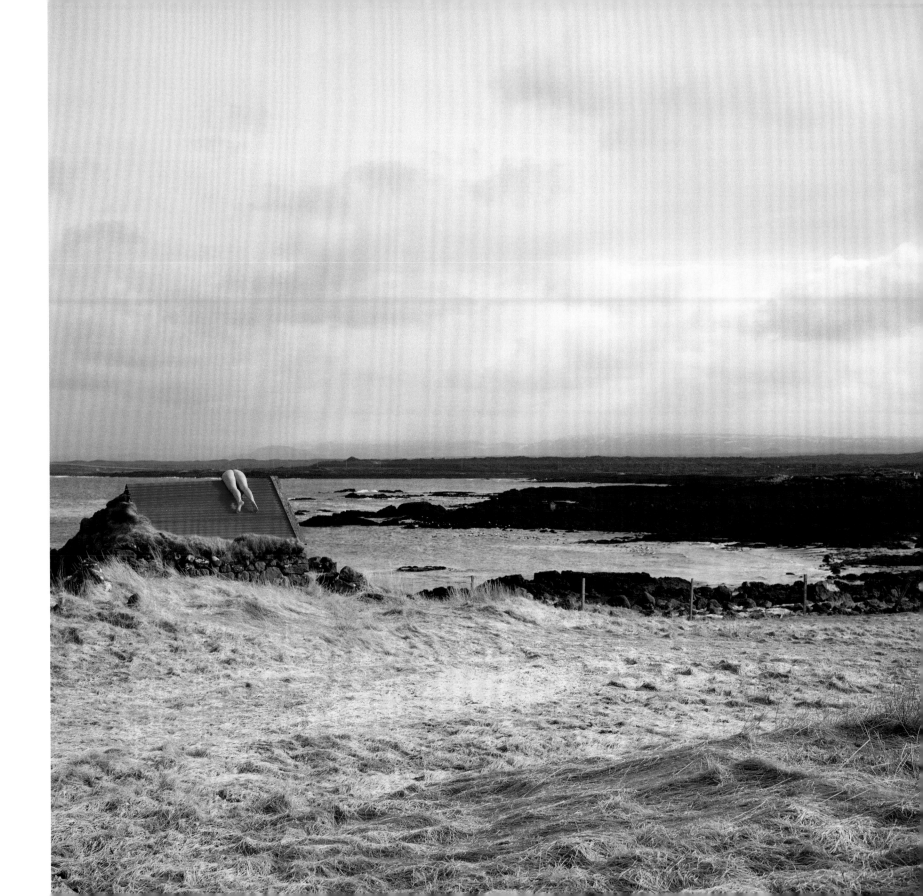

2005.2006

China
Guangxi Province, Fujian Province

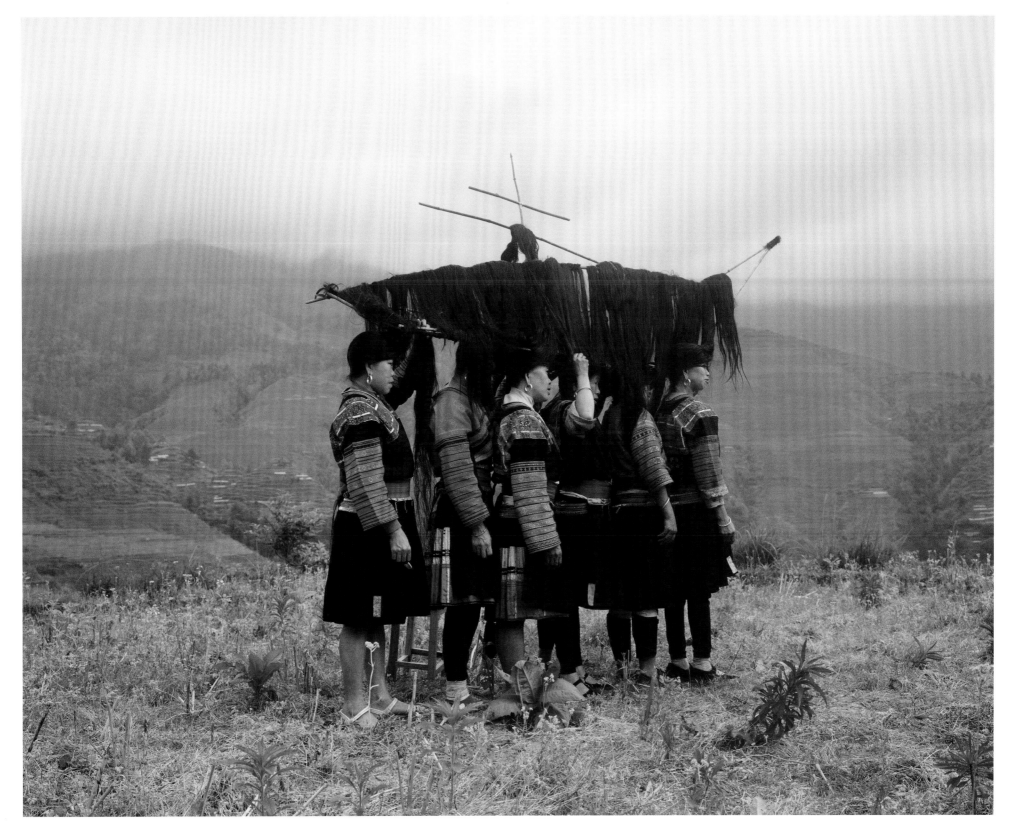

Hair Boat

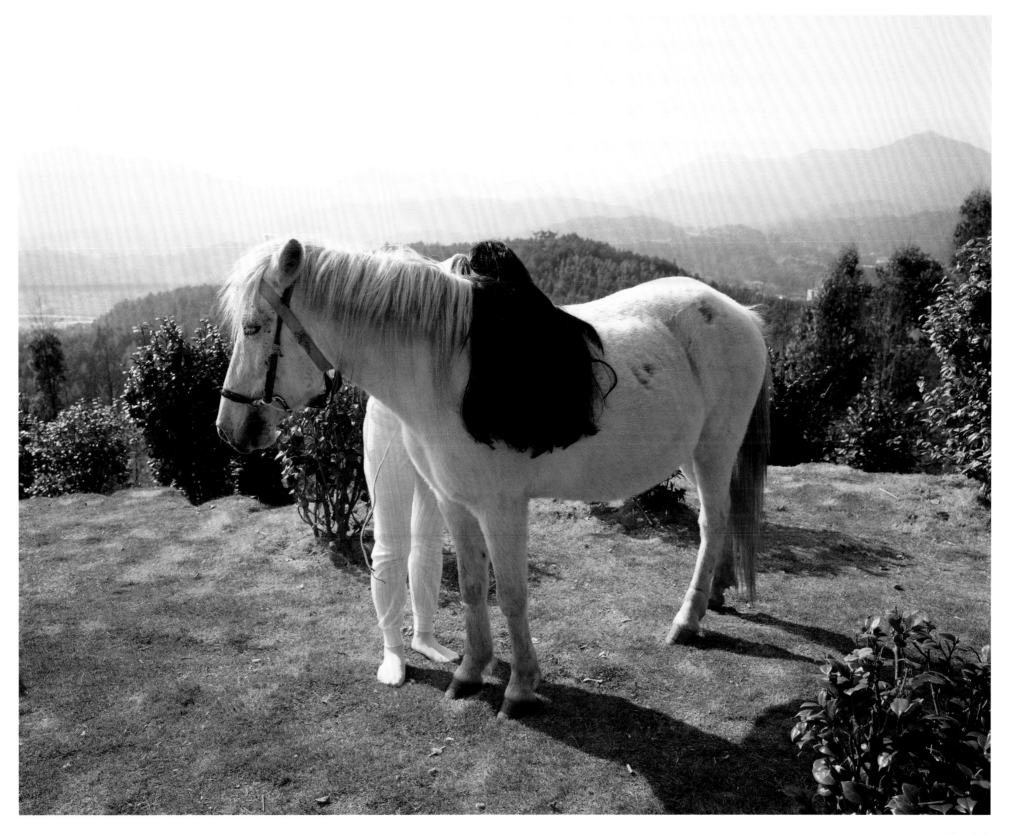

Horsehair

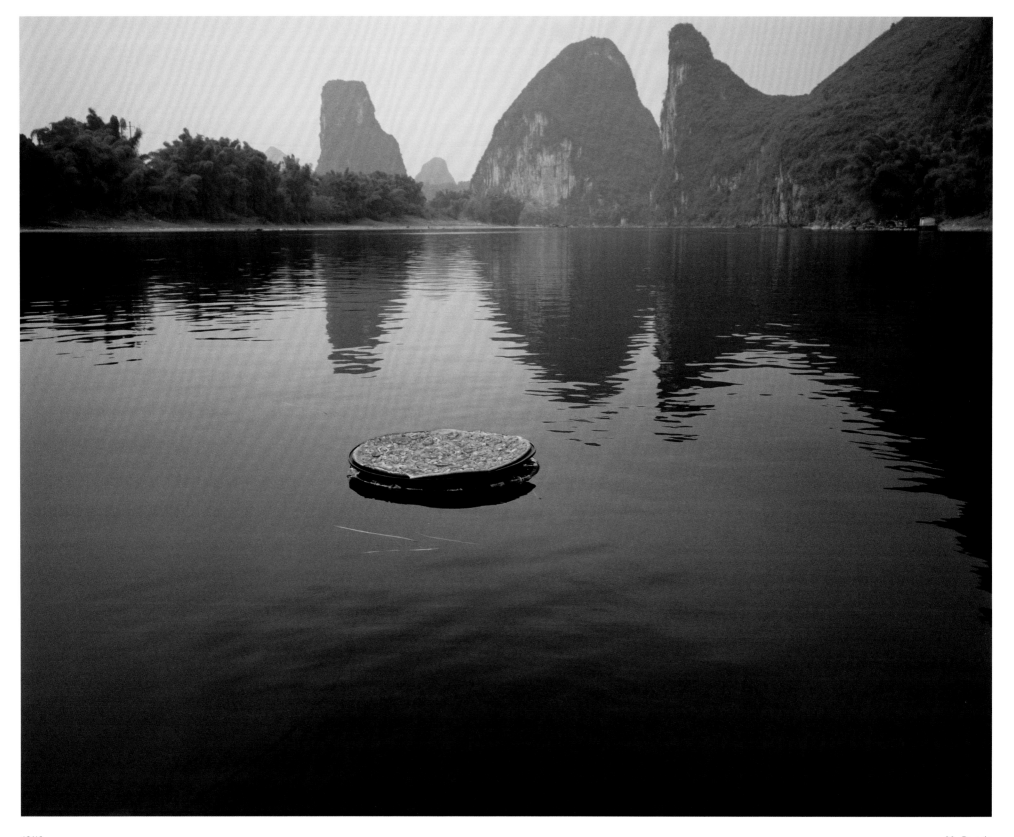

My Bonnie

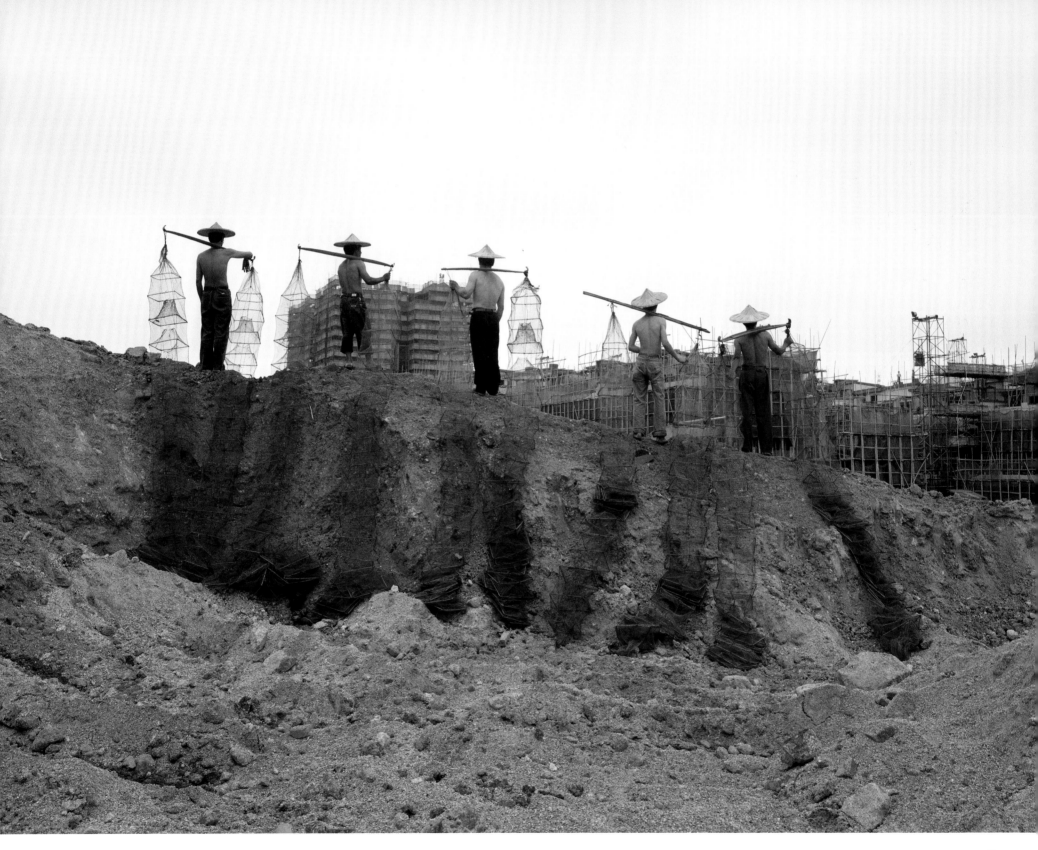

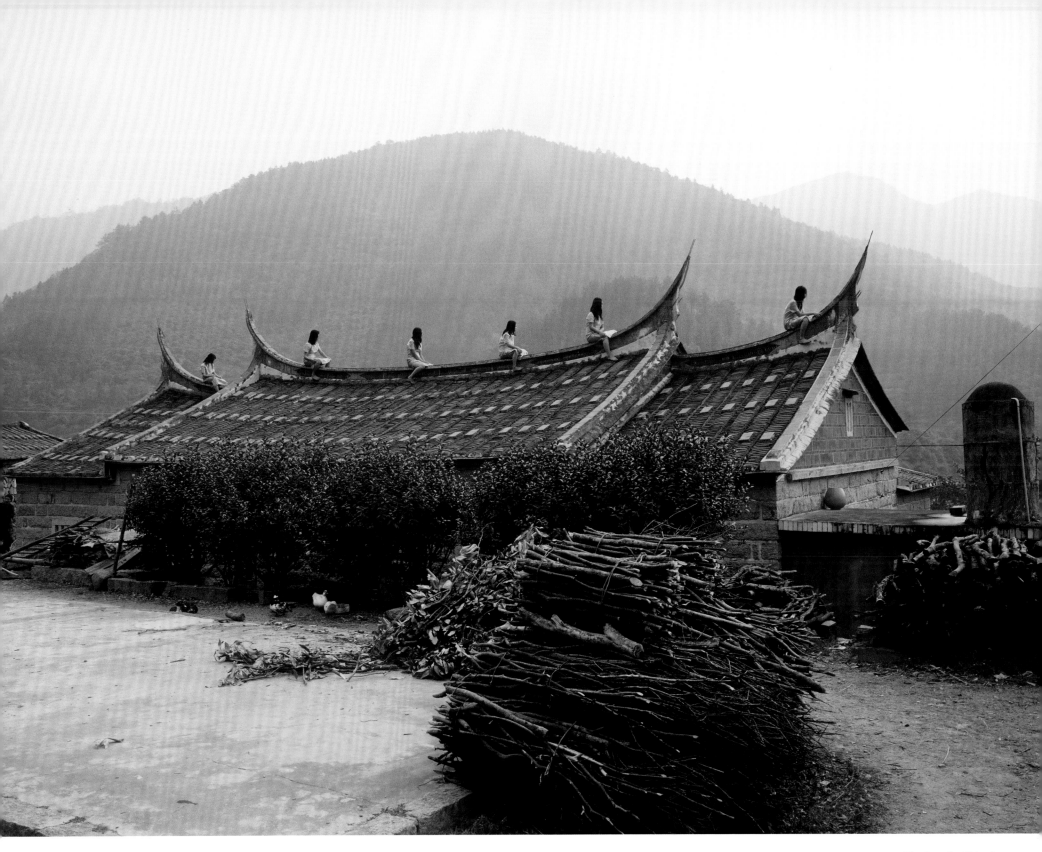

The Day after Valentine

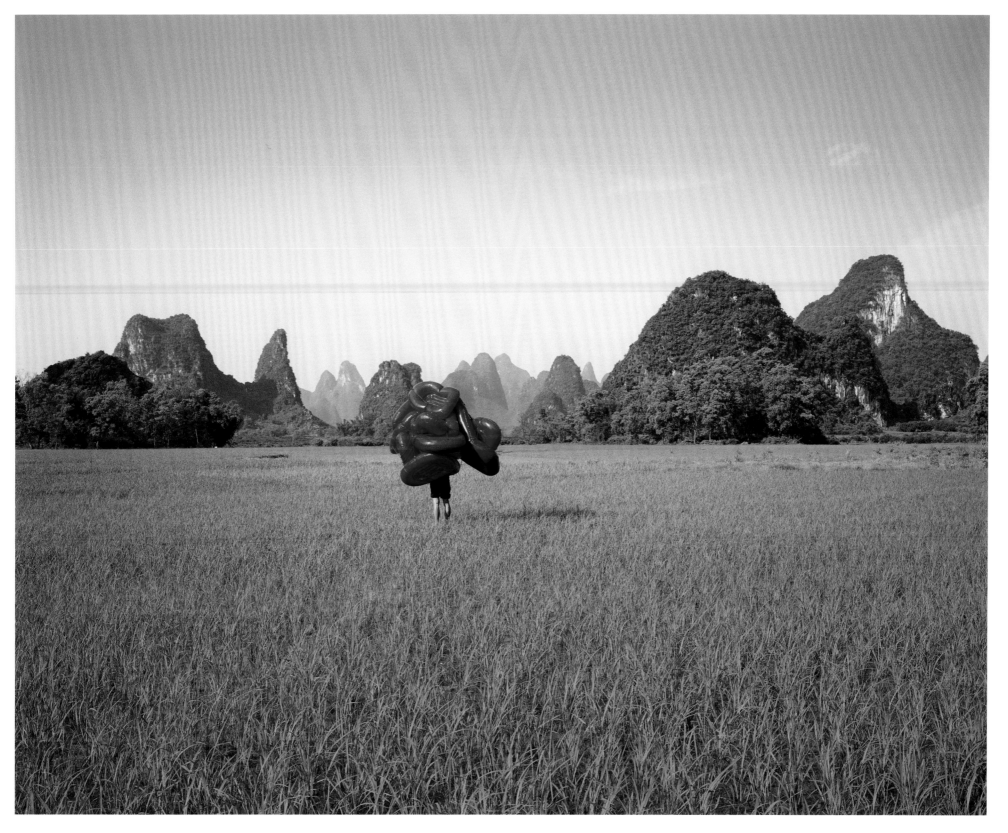

Red Masmo

Bolivia
Altiplano, Salar desert

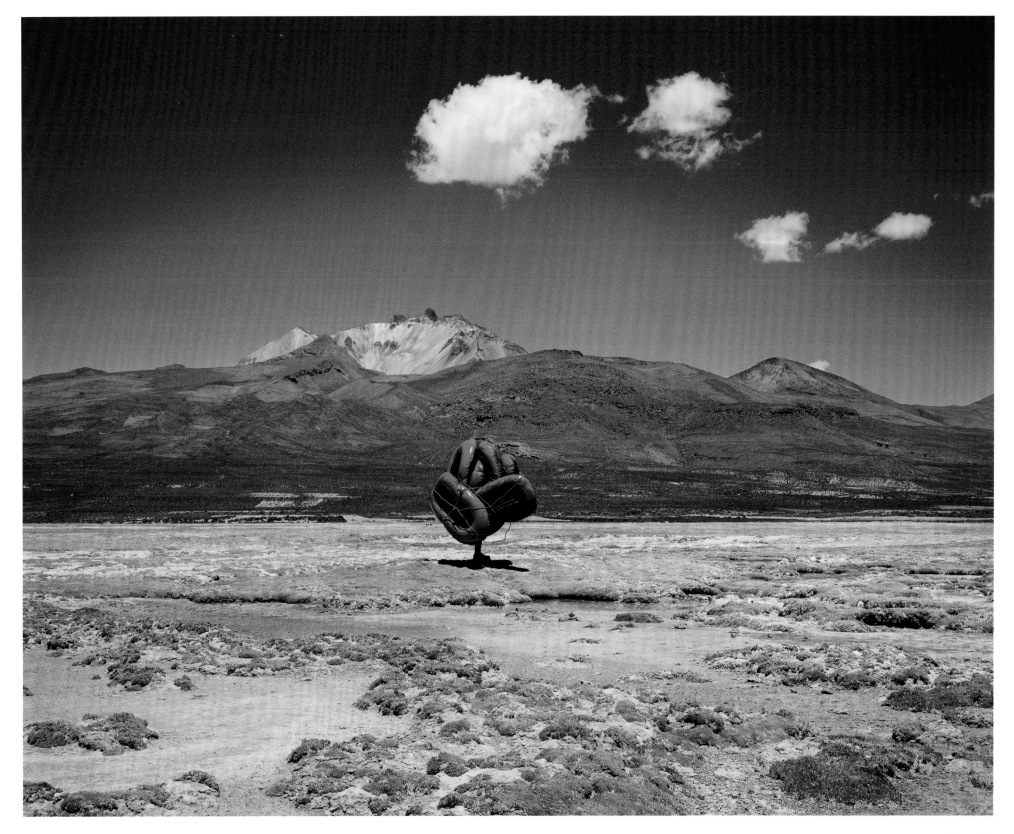

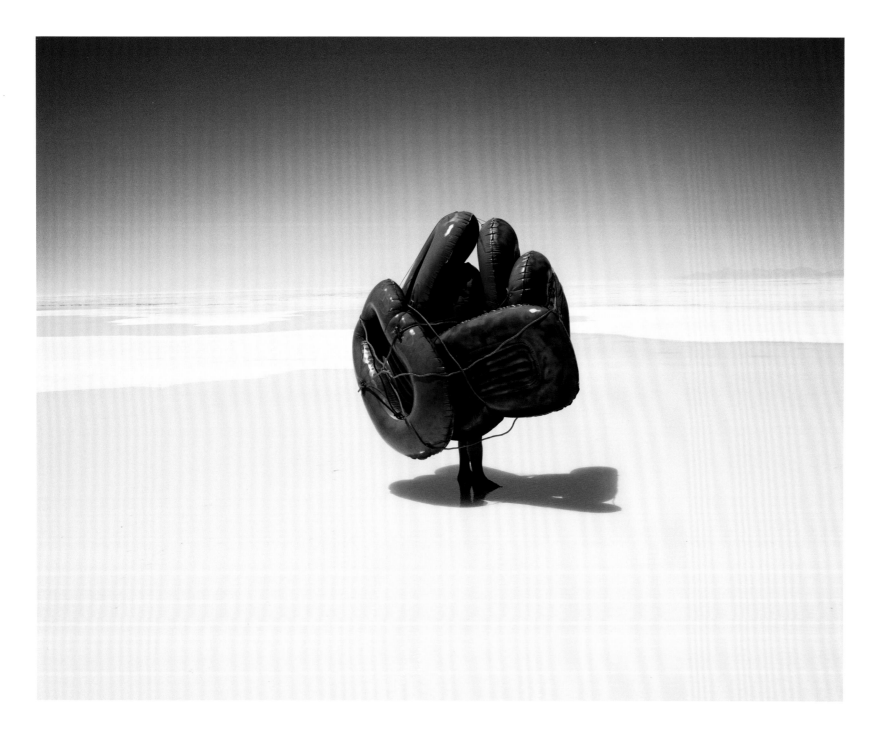

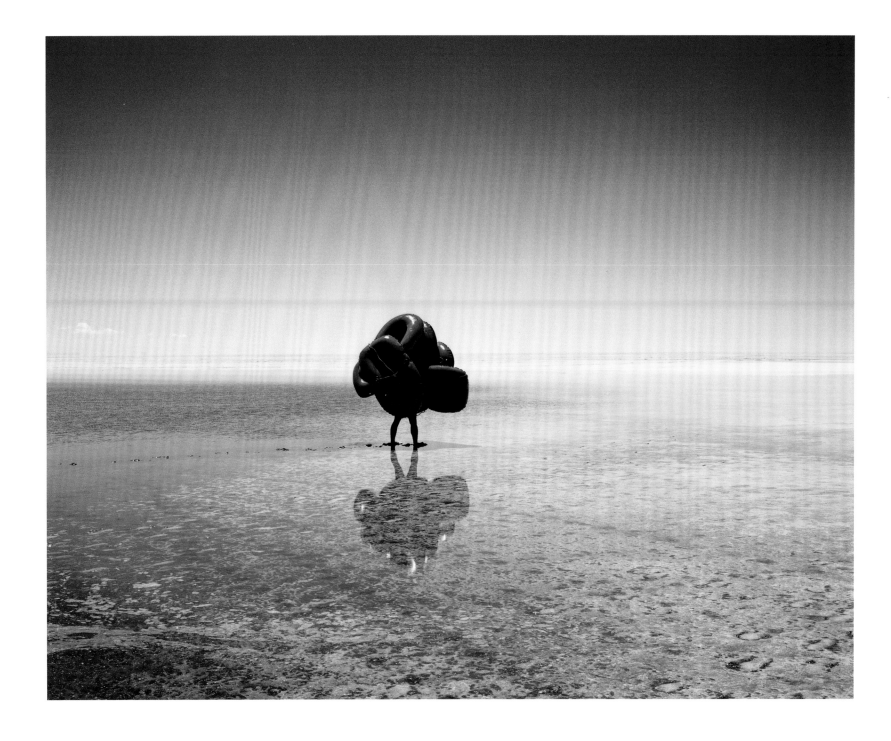

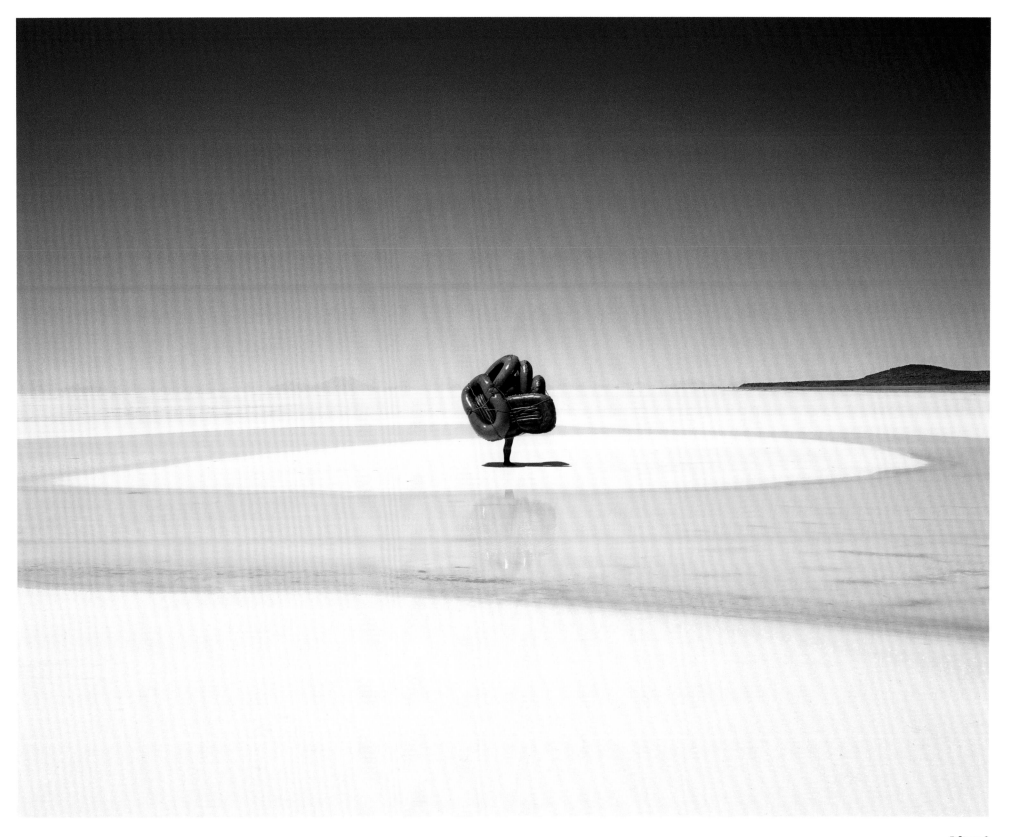

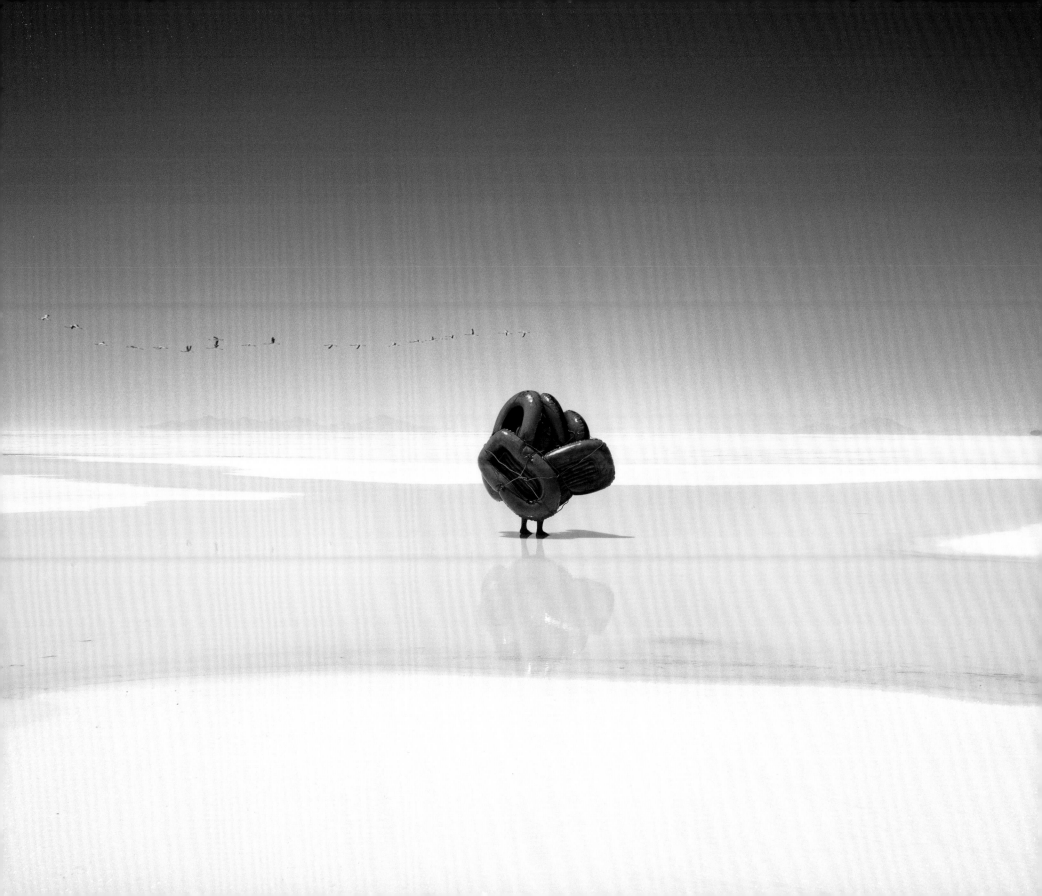

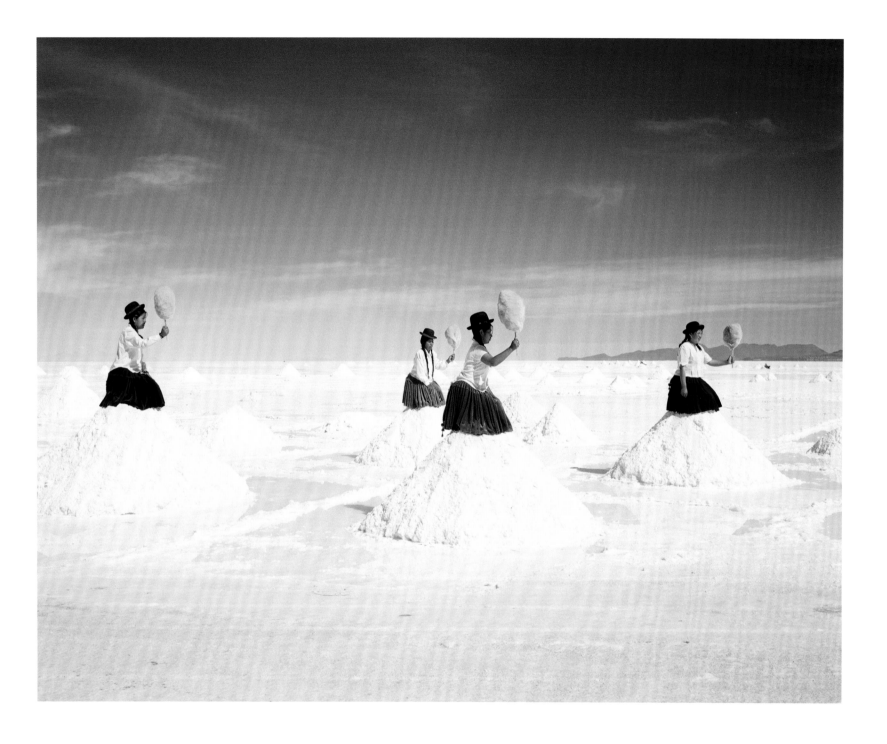

Sweating Sweethearts 1

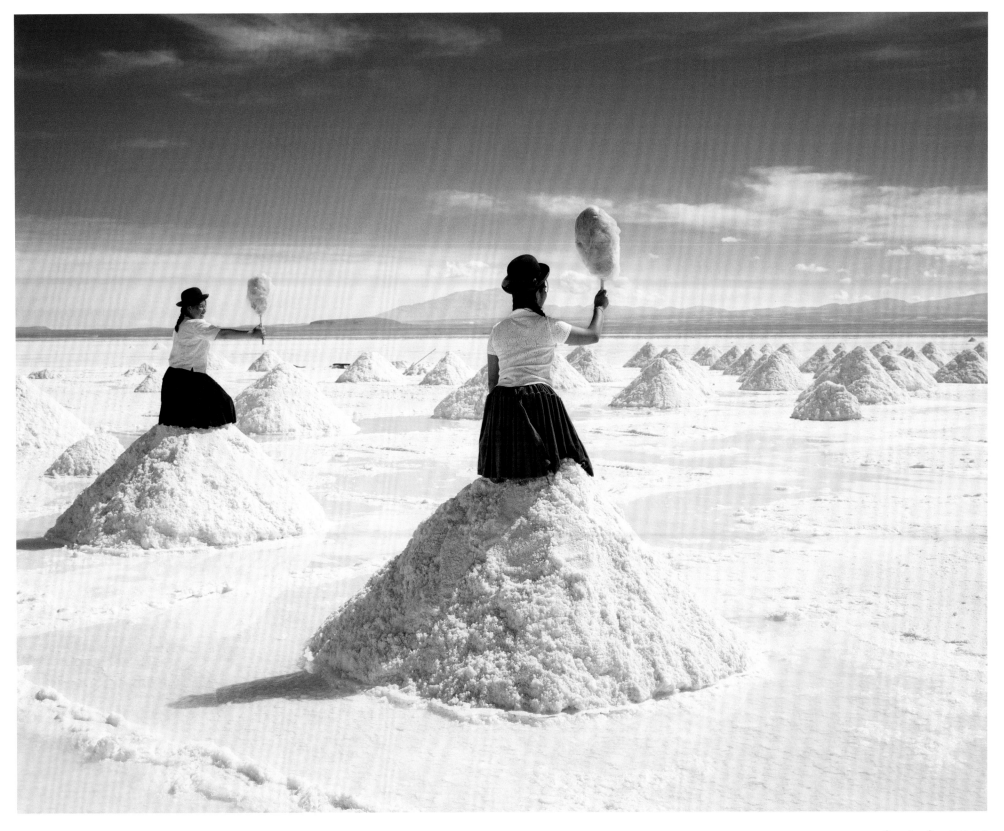

Sweating Sweethearts 2

Domestic Marble

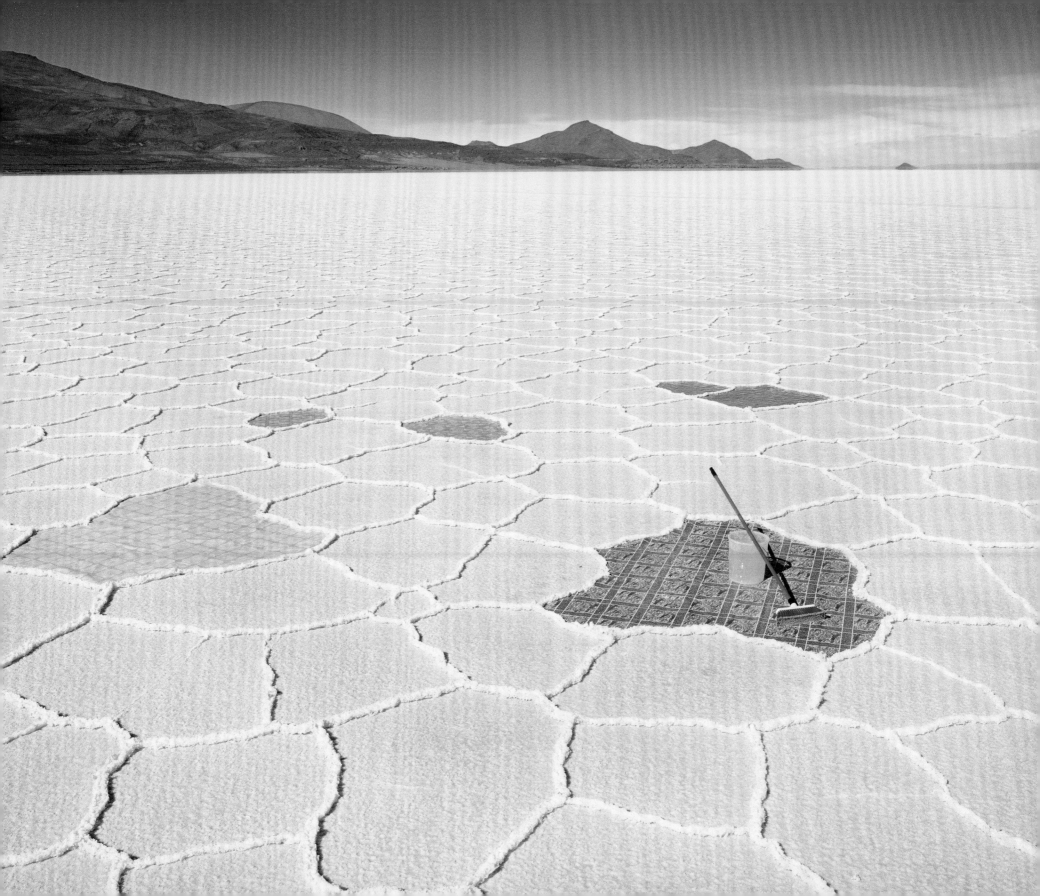

2009

Norway
Jotunheimen mountain area

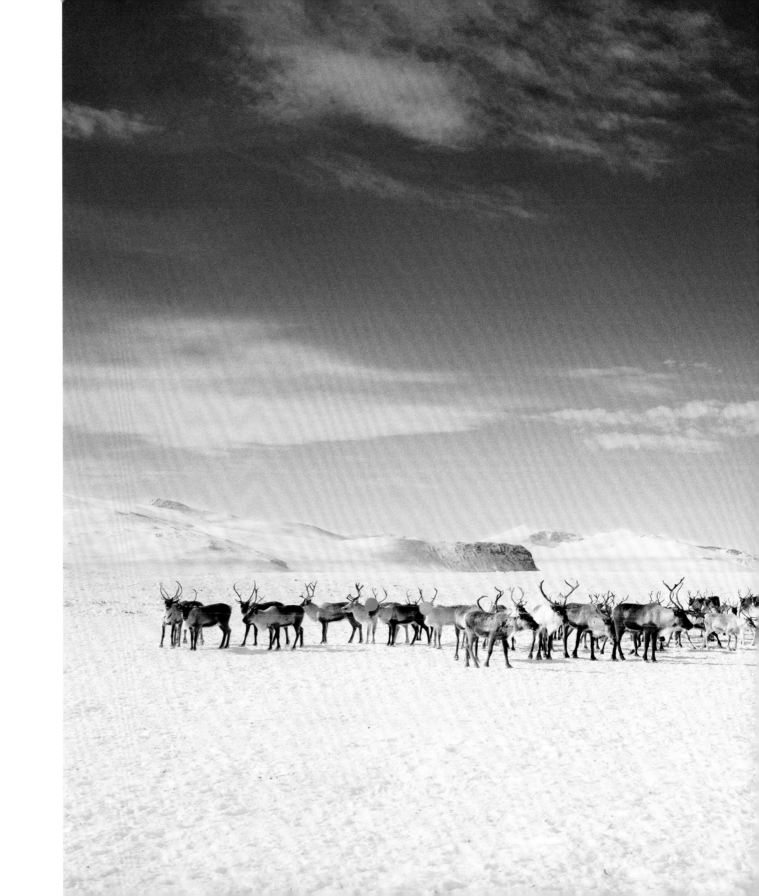

Green + Yellow Dot

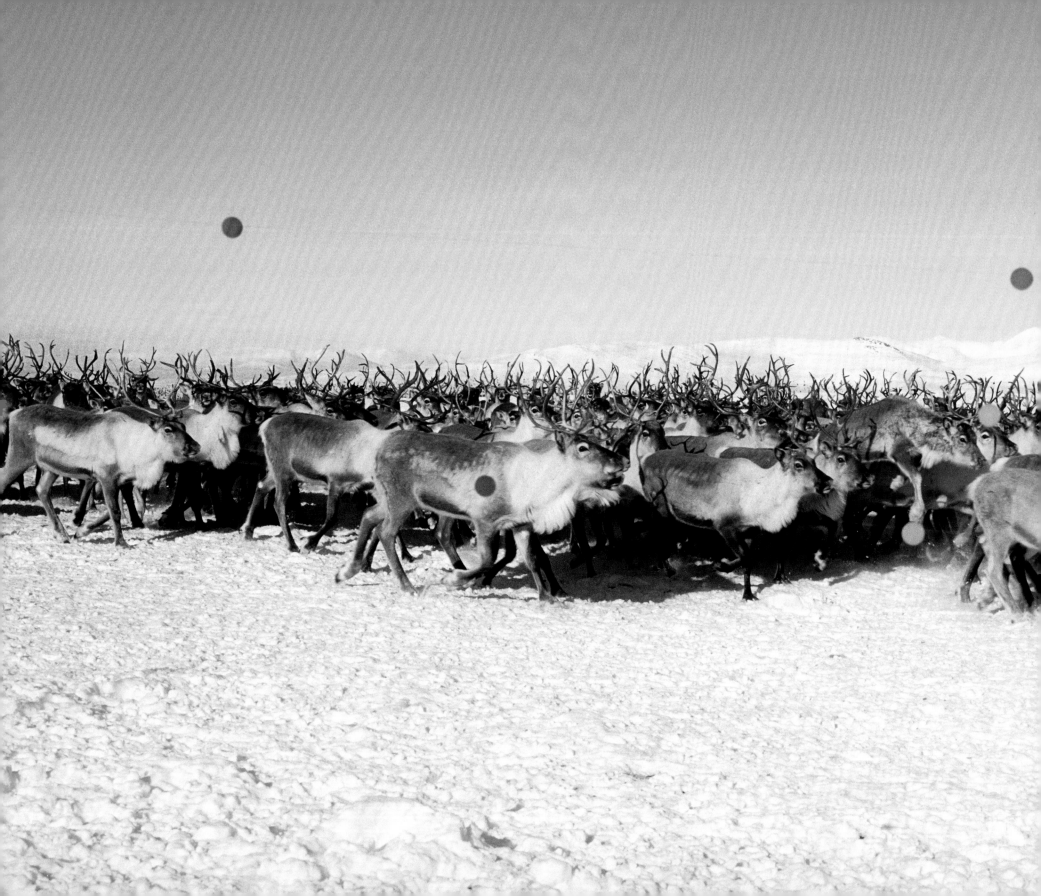

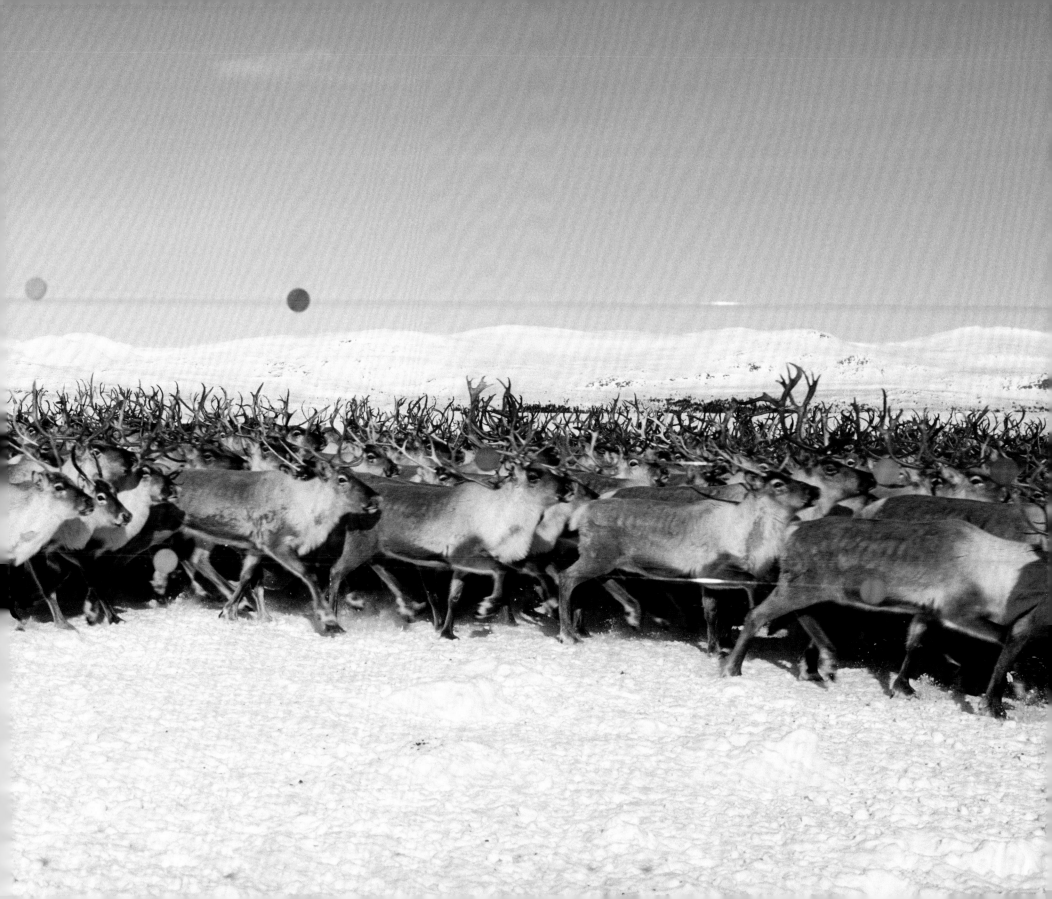

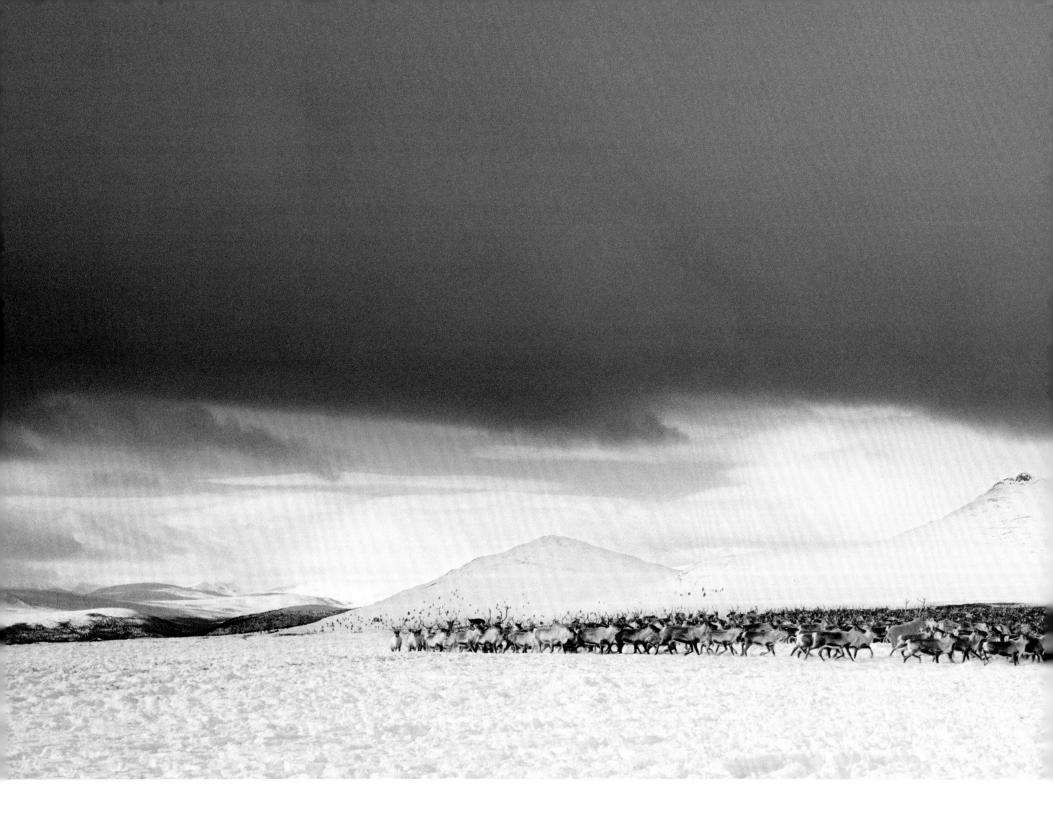

Blue Reindeer in Herd

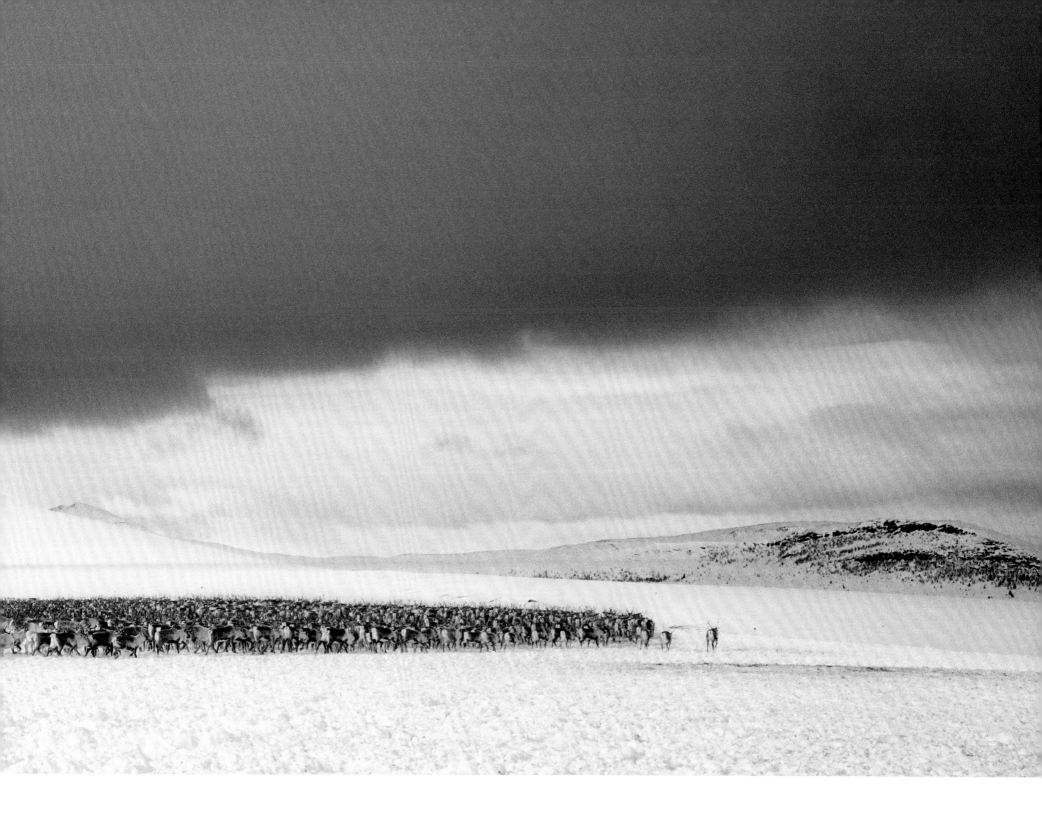

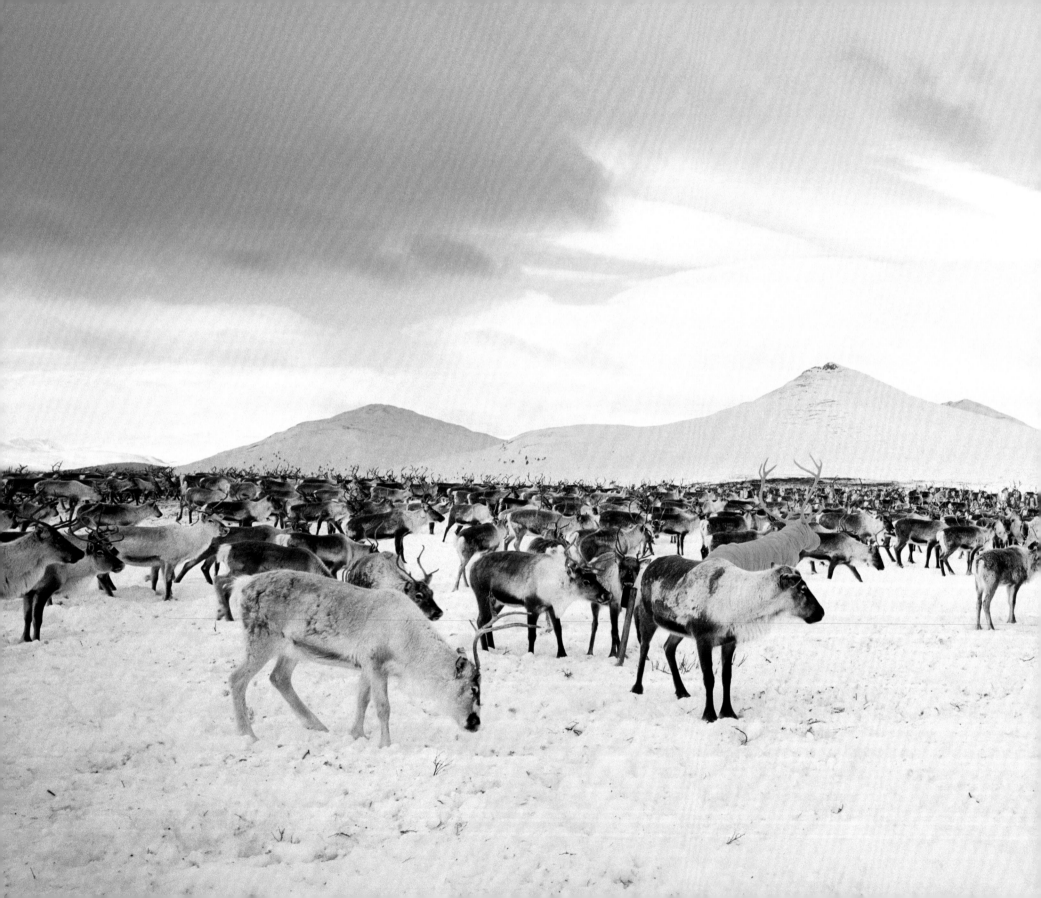

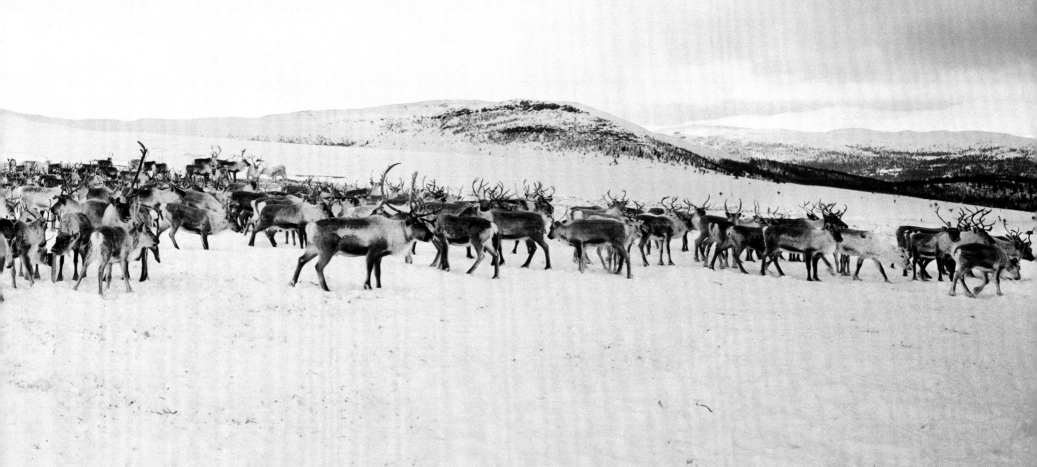

2010.2011

India
Himachal Pradesh, Gujarat

91/92/93

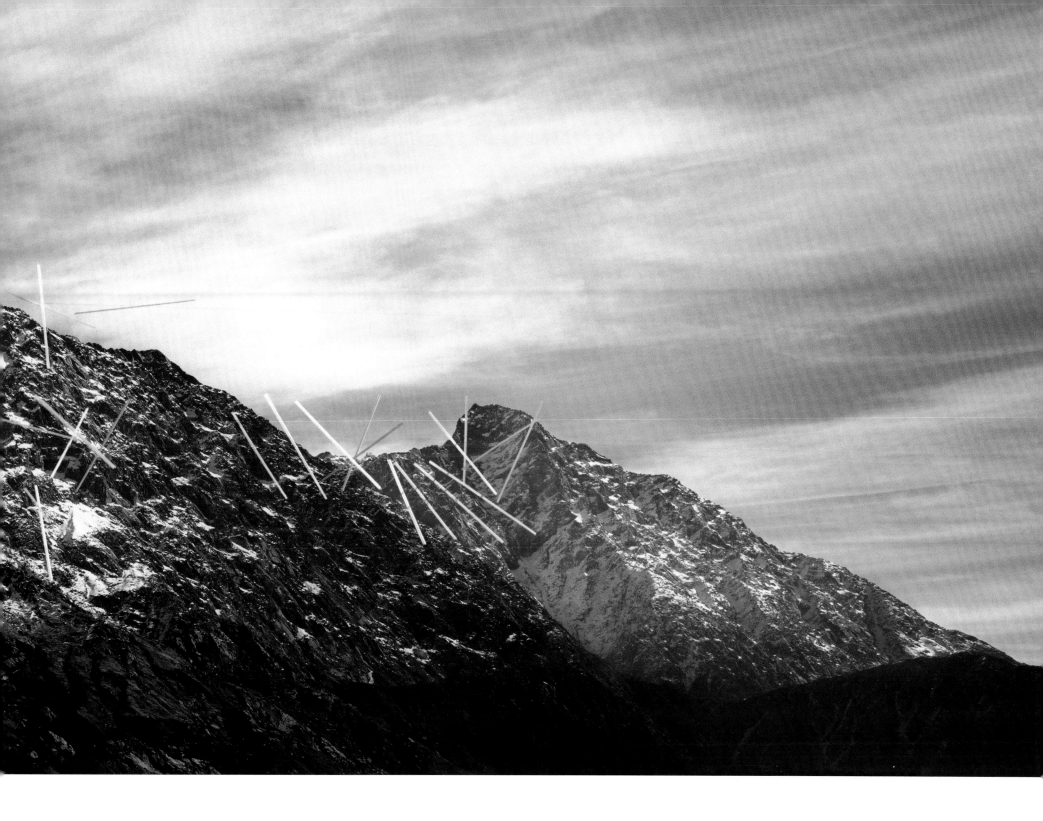

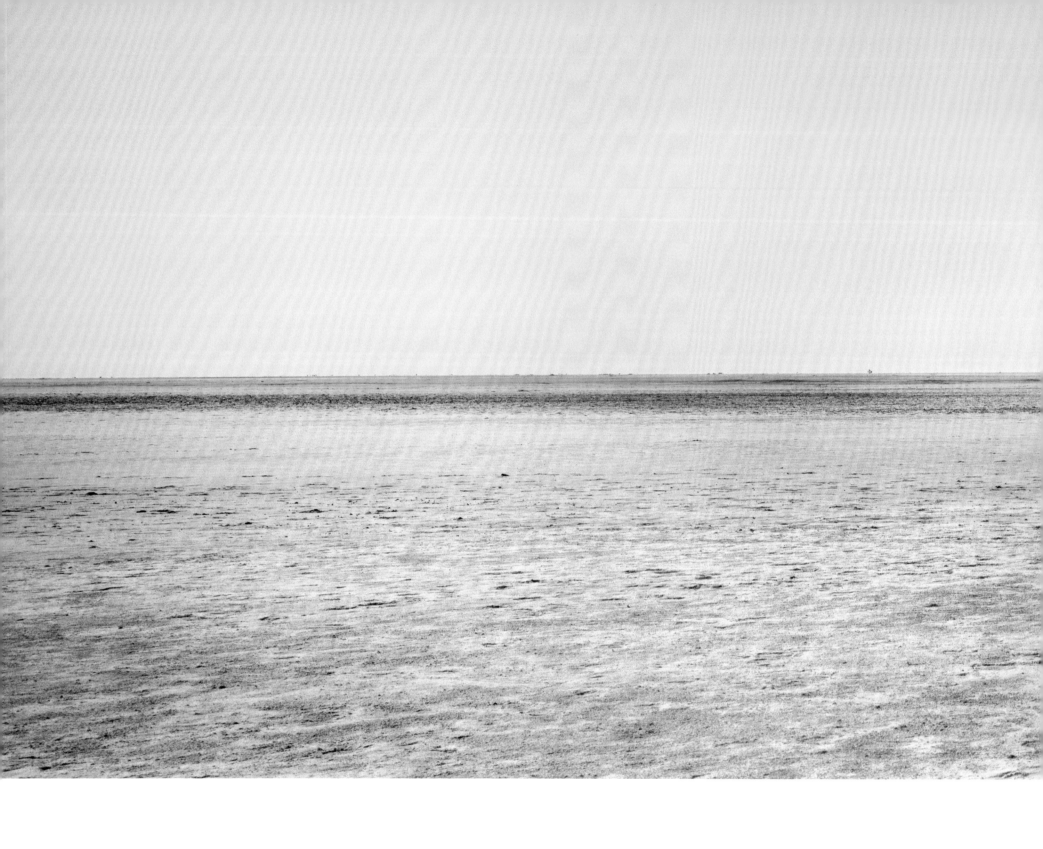

94/95/96

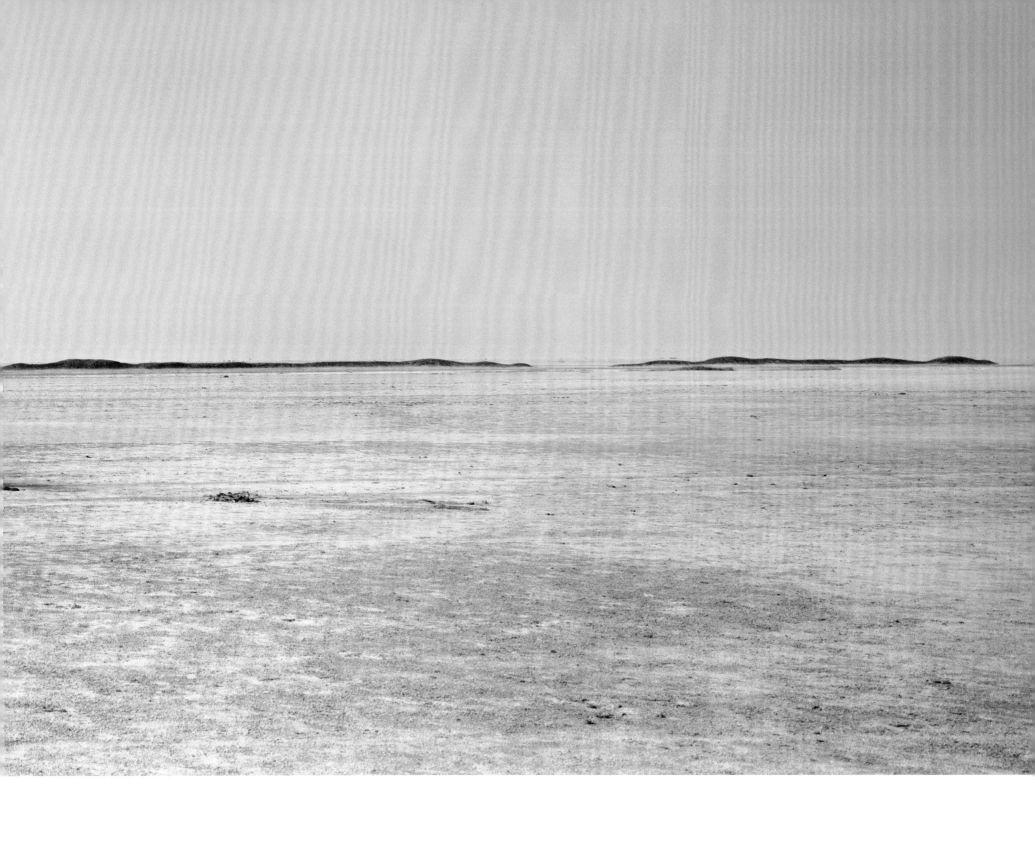

Camels in the Salt

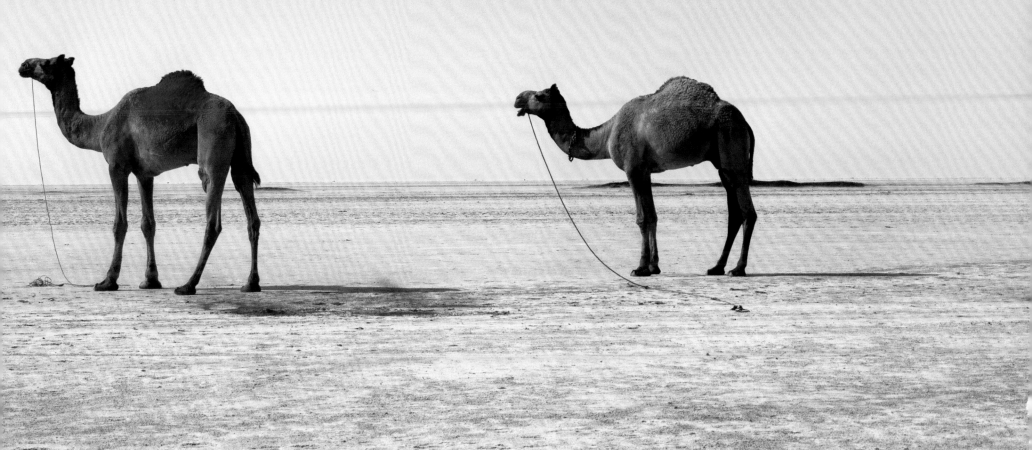

Holland
Schoorl, Gorinchem

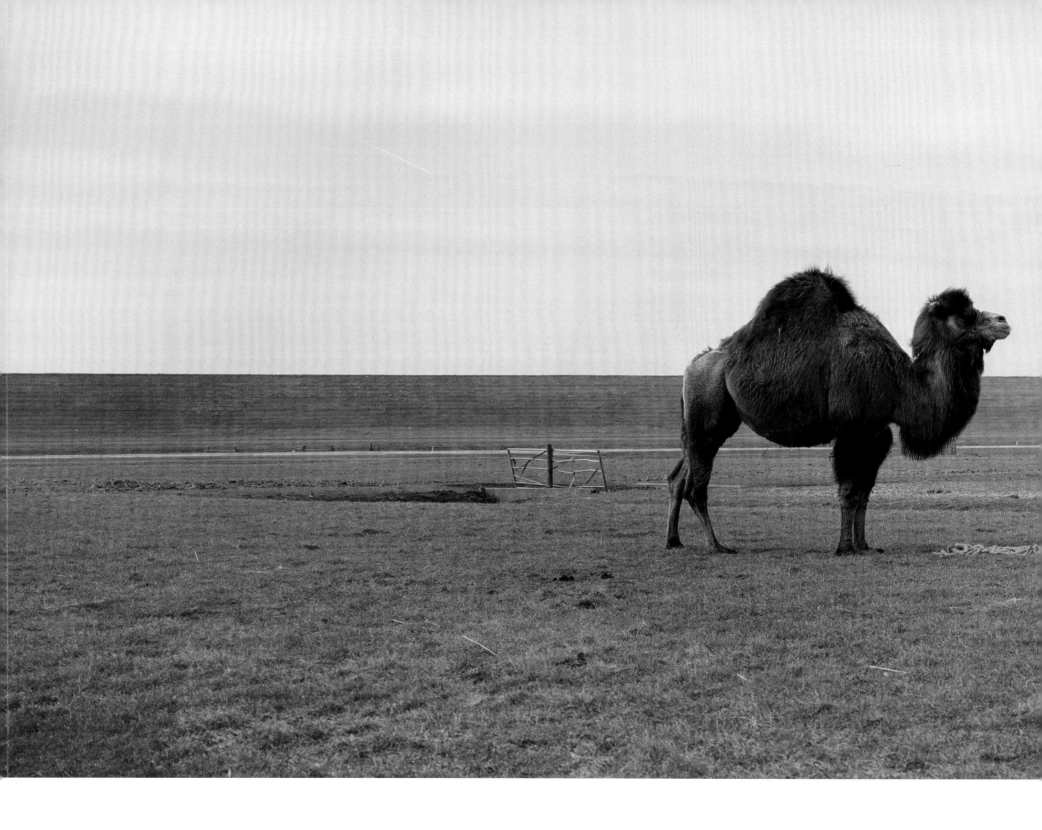

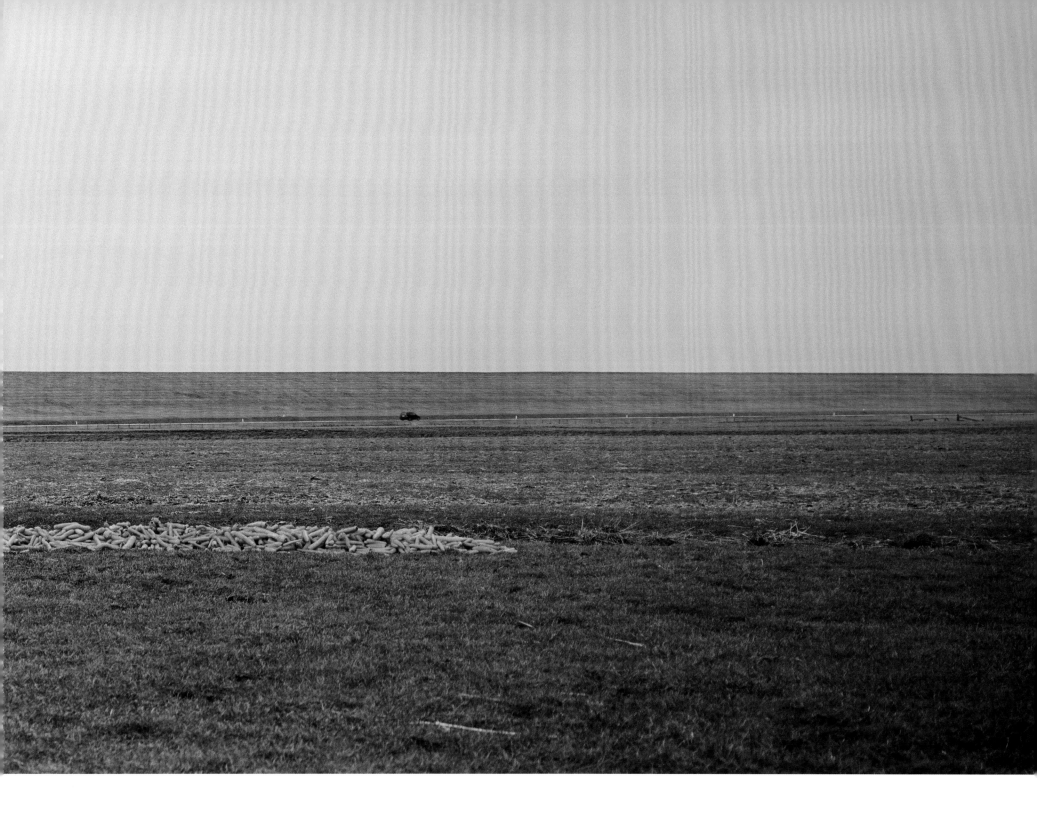

Long Orange Line

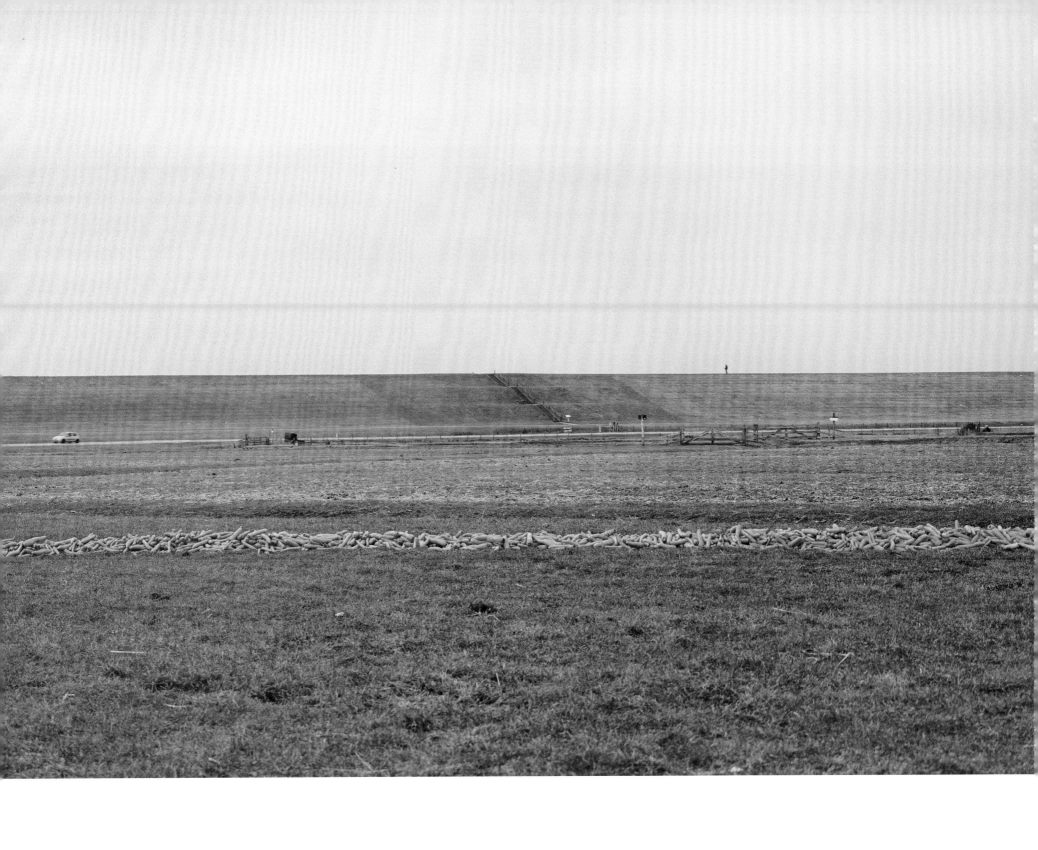

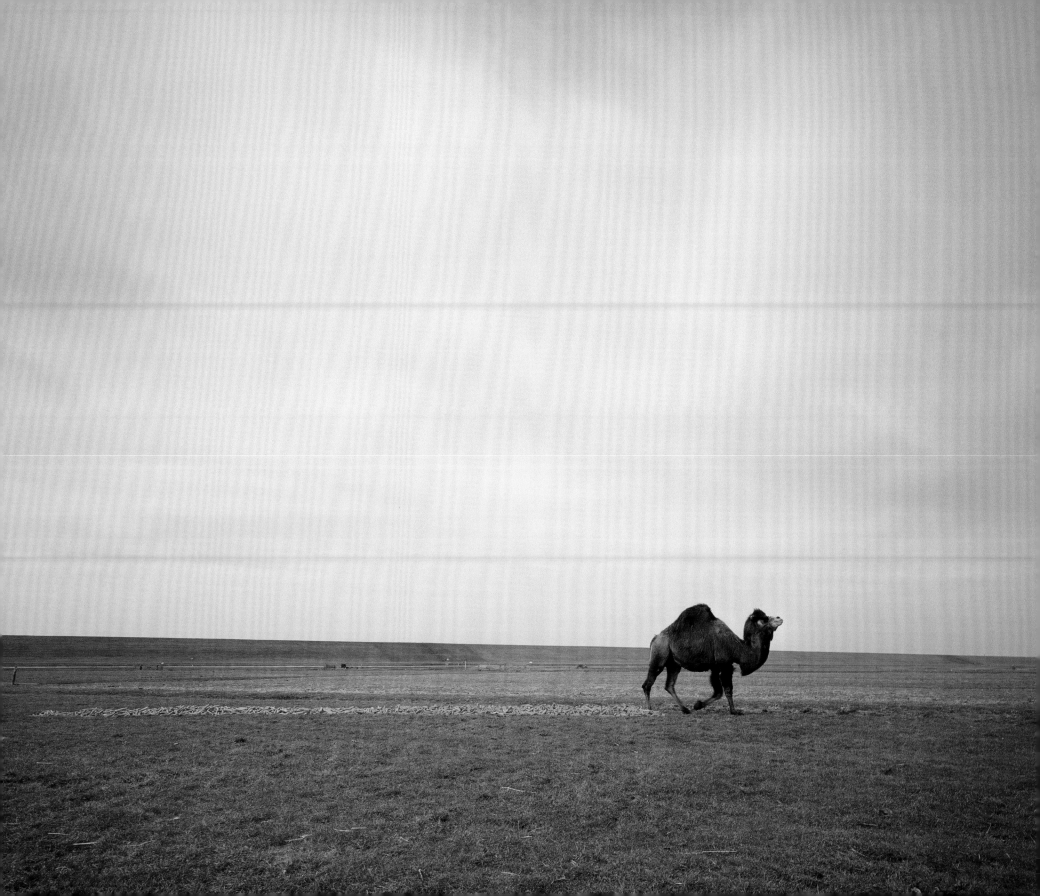

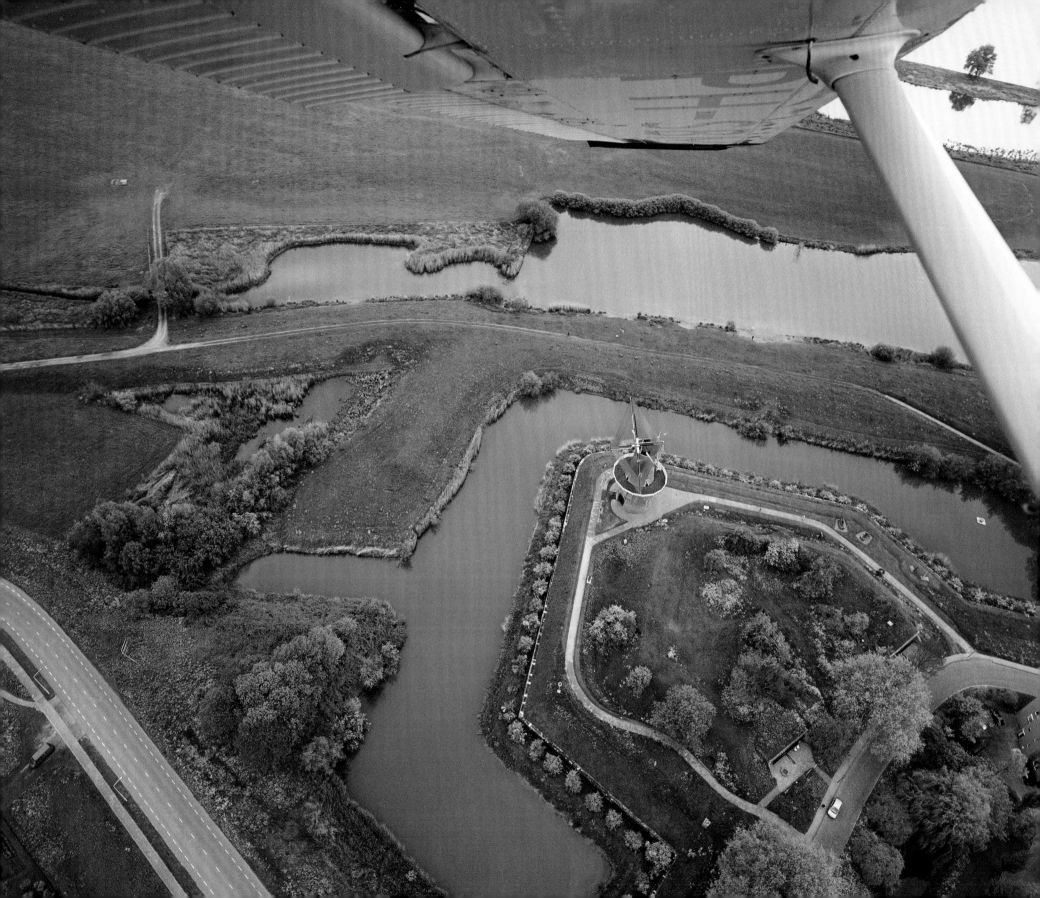

Red Windmill Aerial View

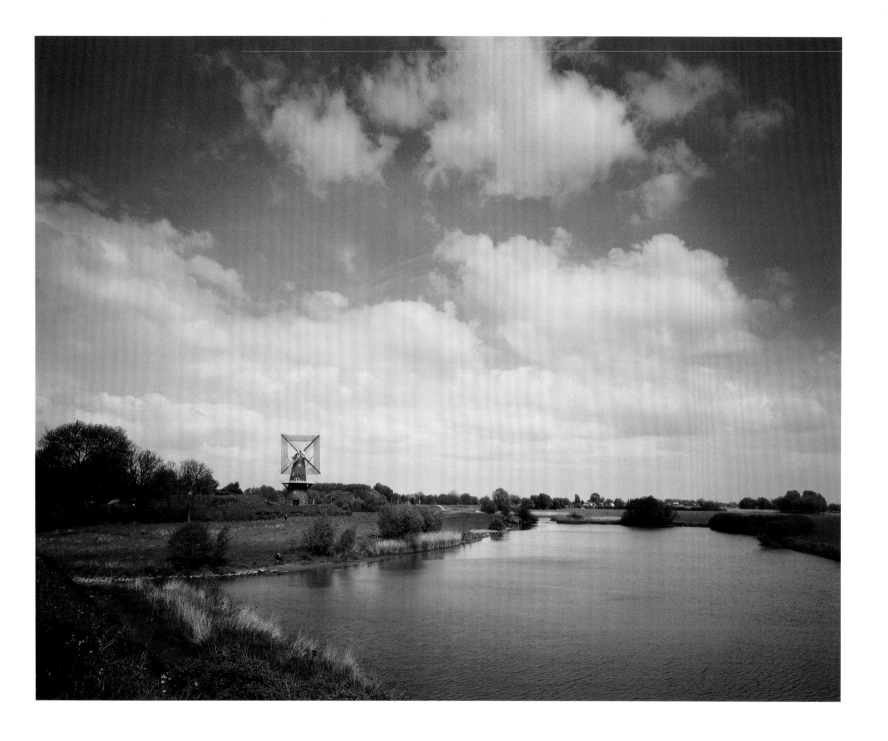

Red Windmill in Landscape

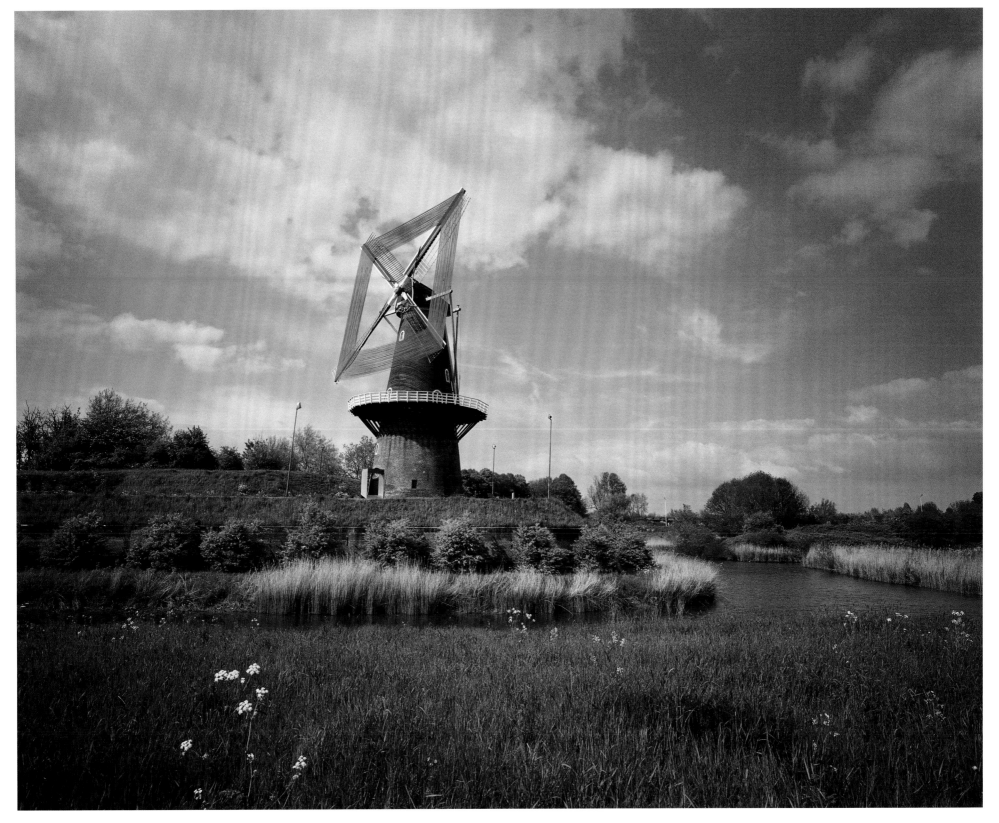

Red Windmill Side View

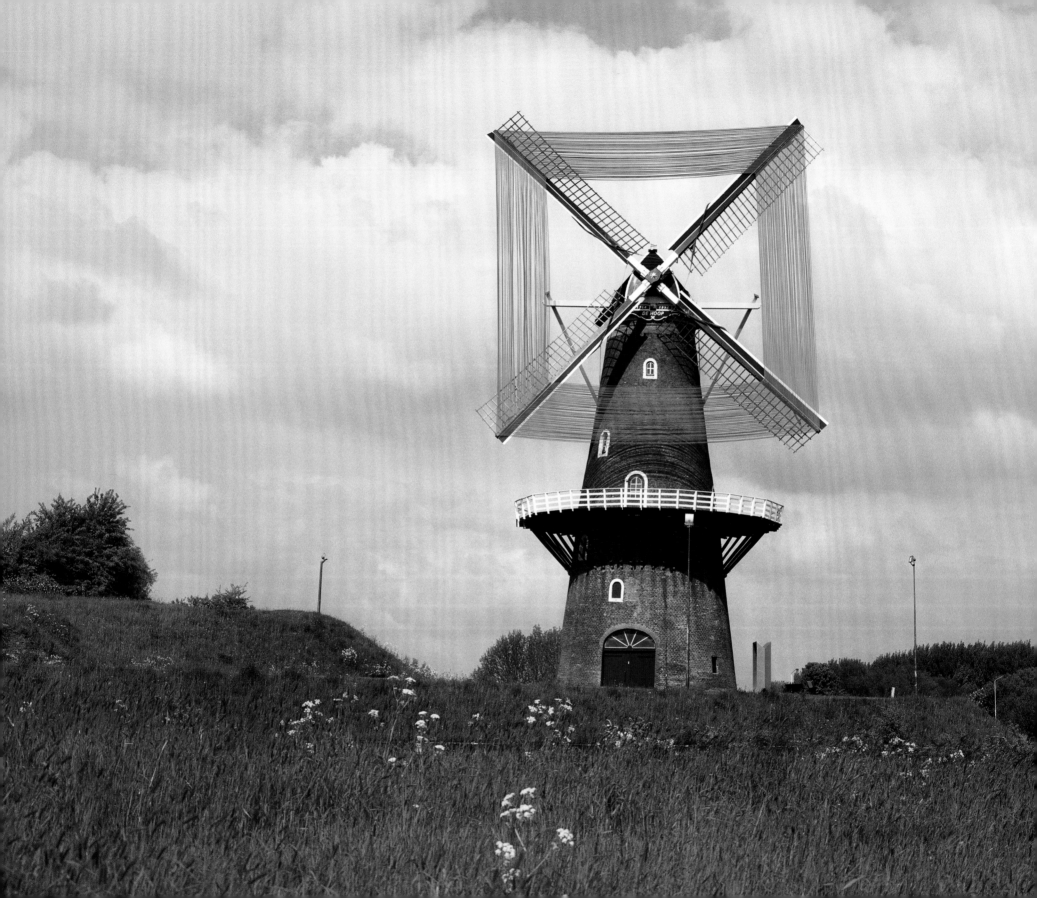

Red Windmill Front View

Biography

Scarlett Hooft Graafland
Born in 1973, Maarn, the Netherlands

Education
2000–2002 MFA Parsons School of Design, New York
1999–2000 Postgraduate programme, The Bezalel
 Academy of Arts and Design, Jerusalem
1995–1999 Royal Academy of Art, The Hague

Selected Solo Shows
2011 *Soft Horizons*, Huis Marseille,
 Museum for Photography, Amsterdam
 Museo Nacional de Arte, La Paz, Bolivia
2010 *Front/Reverse*, Eastlink Gallery, Shanghai
2009 *My White Night*, Michael Hoppen
 Contemporary Gallery, London
2008 *Igloolik series*, Vous Etes Ici Gallery,
 Amsterdam
2007 *Soft Horizons*, Michael Hoppen Contemporary
 Gallery, London
2006 *The Day after Valentine*, Vous Etes Ici Gallery,
 Amsterdam
2005 *Salt Works*, De Nederlandsche Bank,
 Amsterdam
2004 *Reykjavik Roofs*, SIM Gallery, Reykjavik,
 Academisch Medisch Centrum, Amsterdam
2000 *Part time Human,* Gallery Anadiel, Al-Ma'mal
 Foundation for Contemporary Art, Jerusalem

Selected Group Shows
2011 *Pearls of the North*, Palais d'Iéna, Paris,
 galerie xippas
 Contact, MOCCA, Toronto, Canada
 Photo50 London, curator Joanna Pitman
2010 *The Dialogue*, World Expo Shanghai,
 Dutch Cultural Centre, China
2009 UN Climate Change Conference, Copenhagen
 The Art of Photography Show, San Diego,
 curator Charlotte Cotton
 Taking Art for a Walk, Mascalls Gallery, Kent
 Kunst uit huis V Ron Klein Breteler collectie,
 Stedelijk Museum Schiedam
 Nunavut, Our Land, Canada House, London
2008 Hyères photo festival, France
 An Ode to the Animal, Capricious Space,
 New York
2007 *Real Illusions*, galerie xippas, Paris
 Terrains D'Entente, Le Recentres d'Arles –
 The International Photography Festival, France
2006 Chinese European Art Center Gallery, Xiamen,
 China
2005 *Sehnsuchtig gleiten ballone rund um die Welt*,
 Blue Pavilion Gallery, Berlin
 Artist studio Gustave Courbet – Tony Oursler,
 Metropolitan Museum of Art, New York
2004 *How to explain a painting to a dead hare*,
 Kalisher Gallery, Tel Aviv
2002 *Directed Dialogues* Parsons Gallery, curator
 Stefano Basilico

Surreal interventions

The slumped figure wrapped in a polar bear skin, sitting on a step ladder on the Canadian polar ice, is at the very centre of an epic, flat landscape coloured with myriad tones of blues, greys, blacks and whites. The backdrop is as distractingly beautiful as the lone bear, and the scene could be taken from a mysterious feature film or an ad for PETA, the anti-fur campaign. In fact, it is part of a series set in eight remote locations in which Scarlett Hooft Graafland has devoted her working life to since 2004. The careful choreography at work here and the almost surreal drama infuse all fifty photographs in this book.

Scarlett was the polar bear model, freezing cold inside the skin and a surprise intervention in the landscape; usually, she is photographer, designer, set and prop maker and choreographer on the carefully planned shoots. In this other role, her chosen posture is strangely anthropomorphic and despairing and, given the future of polar ice, represents the polar bear's fate.

Having grown up in the flat landscapes of Holland, it is hardly surprising that Scarlett is attracted to other vast landscapes with infinite horizons. Her first project was in Iceland where she lay naked, bent over like a Gormley statue, on the apex of roofs overlooking the soft, mossy landscape. Lying motionless, she merges into what is a strange, surreal open space. 'In Iceland you can find tiny houses in the middle of empty landscapes, used as shelters,' she says. 'Those pointed roofs look so homely inside but to lay on top of them, it would feel out of place, vulnerable. And here, surrounded by lava fields, to lie on top of these tiny houses just emphasises the strangeness of the scene.'

'I'm always searching for incredible landscapes,' she says, 'And I like the fact that the results look like they are photoshopped. But none of my work is digital. The Icelandic landscapes are so surreal with the moss and the lava and I enjoy that it's hard to convince some people that my photographs are all analogue and printed in laboratories.'

Scarlett avoids the perfect photogenic locations that attract travel photographers and tourists because she is searching for somewhere that accepts the concepts she's working with. Colour plays a major part in her photography, and she is drawn to different palettes, but a main attraction is clearly the tonal range of whites, blues and greys in her vast landscapes. 'I was really fascinated by the lakes in Bolivia,' she says, 'The red, white and green lakes were the reason for going there, and I chose to focus on the whiteness of the Salar salt desert in the high Andes.'

With a background in fine art, textiles and sculpture at the Royal Academy in The Hague, a post graduate programme at The Bezalel Academy of Arts and Design in Jerusalem, and an MFA in Sculpture at Parsons in New York, Scarlett's main references are to Land art and sculpture. They permeate her photographic practice even though she only took up photography eight years ago. Many images in this book, including the 'carpet' drawn on the salt desert's surface in Bolivia with coloured powders and the windmill project in Holland, draw on her academic training. Working in New York as a studio assistant for Tony Oursler was also a significant influence.

Preparation for every project is intense and can take months of researching and preparation, designing sets which transform settings and the constructing of props on site. 'I like to research materials locally and get local people involved in the projects.' In spite of the beauty of Scarlett's work, she is drawn to people who live in terrible circumstances and to the many disappearing cultures. 'The Inuits in Canada, the Bolivian ladies with their bowler hats, the Chinese fishermen who are losing their work, all are raw, disappearing cultures. I try to set up photographs in a light way but it's no coincidence that they cover such threatening issues.'

When Buzz Aldrin and Neil Armstrong looked down to earth from space, they spotted large white patches in southern South America and assumed they were glaciers. When Armstrong checked them out at home, he discovered the Salar salt desert. He took a trip organised by Bolivia's most infamous and celebrated artist, Gastón Ugalde, whose Salar gallery in La Paz illustrates his inspiration from the salt desert. Gastón became a crucial fixer in Scarlett's Bolivian projects. Her reaction to Salar was clearly one of excitement, but even for an outdoors, strong woman, it was physically challenging: 'Lips hurt because of the salt in the atmosphere, the sunlight is strong because it's reflected off the white salt, and there are very high altitudes there, about 4,000 metres, a very hard place to live and work.' It is also sublimely photogenic and led to five visits for this book.

Perceptions of the miners handling silver or salt are, naturally, different. 'The men scrape up the salt by hand and build pyramids, then they load it by hand onto the trucks. They wear balaclavas to keep salt from their skin and the women's bowler hats protect their eyes.' Salt pyramids dotted across the landscape like haystacks in fields become props in her sculptural interventions, following a line to Richard Long's environmental art.

The most magical series in Bolivia is *Sweating Sweethearts* where Scarlett seated bowler-hatted indigenous women on the salt pyramids and set them regally waving pink candy-floss lollipops in the air. 'I wanted to put them on a pedestal because they live in such difficult circumstances,' she explained. 'Getting permission from their husbands to pose for these photographs was difficult but when

they sat there, they loved it.' The elegance and beauty of the scene raised laughter – and delight. 'One woman was still laughing when I took the shot.'

Bowler hats and coloured balls are favourite elements in the Bolivian portfolio. Hats and balls are suspended on almost invisible threads, they float over misty steam rising from geysers or are strung across the sky in a knowingly Magritte-like, three-dimensional installation. In every different landscape, trees are absent. Not even in the green tree series, where a ball of green inflated rubber boats is carried by a tall man, invisible but for his legs. A 'tree' planted in a shallow layer of brownish water indicates the presence of lithium below the surface, a reminder of this most precious metal's future significance for Bolivia's economy for use in batteries for electric cars. The salt desert is increasingly the most fought over space in the world. Planes land eerily on the salt, and exploratory forays for lithium are increasing. What today is a quiet, magical place faces transformation – but not in the way of this artist's sensitive, surreal intrusions.

Moving from Bolivia to an Inuit community in Igloolik, Canada, in 2007/2008, Scarlett brought a large white weather balloon to the village on a sledge pulled by dogs. She introduced it into several pieces of work, including *My White Night*, when she took the ball outside at night. 'Under a mysterious light and clouds. It sits like a white moon.'

Amongst the Inuits, Scarlett's background in sculpture was exercised. *Lemonade Igloo* was built with blocks of ice made in wooden boxes lined with plastic sheeting. She added water and orange-red lemonade powder. 'In Holland, lemonade is orange,' she explains. 'I found the one man in the community who is a traditional igloo builder and he put the blocks together.' But it was difficult to get

permission to build and the Inuits refused at first, saying that making an igloo as an 'art piece' was not a good reason to build it: igloos are made to be used. This was an ice igloo – slightly transparent and issuing a seductive glow and much more difficult to make; it took weeks to prepare, but just one day, at -25 °C or more, to build. The solution was solved when Scarlett decided to build it next to a school and give the children lemonade inside the igloo. Then the builder, Nathan Qamaniq, decide to go ahead. 'Only the traditional, older people still know how to build ice igloos,' Scarlett explains, 'but everybody can build snow igloos.' Unusually, she decided to document the process photographically, taking snapshots on a small digital camera to show how the coloured ice blocks were transported on a sled with a snow mobile and made into the igloo.

The result was a glowing reddish dome suggestive of a Marc Quinn blood project. It stood there for many months and became a place where young kids were hanging out. The companion piece *Wrapped* is a conventional white snow igloo, wrapped with metres of golden yellow cord borrowed from the hunters. The inspiration, she says, comes from the transparent igloo domes made by the celebrated Arte Povera sculptor Mario Mertz. The reasoning behind *Lemonade Igloo*, she explains, is 'the generation clash: the young don't know how to make igloos; they drink pop and lemonade and sit at computers all day; 50 per cent of their village is under fifteen.'

The simplest of the snowy works is *Palm Tree*, drawn in outline on the snow using the entrails of a seal. 'I was travelling on the ice with a hunters family in a sledge and came across this pile of blood and meat. The Inuit thought I was mad to make a drawing with them and sat inside the warm tent. But I knew it was something I could make a drawing out of.

And you don't see trees there; I missed them. I was thinking of the neon palm tree signs.' I, however, was thinking of Tracey Emin's early pink neon tree.

Moving south to Norway into the Jotunheimen mountain area, Scarlett stayed with the Sámi people and their herd of 2,500 reindeer. Here, she made panoramics which perfectly capture the design effect of the horizontal bands of sky and snow and the subtle beauty of the reindeers' muted pattering. The purpose of the visit was to construct a blue reindeer from garbage bags. A local shepherd helped in the construction and in placing the bizarre animal in the landscape where the herd would graze. 'I wanted to give it an identity amongst the seemingly identical crowd; I wanted the deer to stand there like a black sheep. It was a commission originally for the psychiatric department of the AMC, Academic Medical Center, to represent individuality.'

Scarlett also introduced small coloured balls suspended on almost invisible wires over the herd. 'A few would hang over the heads of some of the deer – and those would stand out as individuals. I like the way John Baldessari played with coloured balls, making graphic collages on photographs – but I liked the idea of doing it with real balls.'

While working in South China in 2006, Scarlett completed several projects linked by the social and economic realities and the fading customs and lifestyles in the face of rapid urbanisation. In the city where she stayed, local fishermen were losing work to a fast-growing new part of the city. She arranged the men standing in a row holding their nets and facing the buildings whose scaffolding cover was the identical tone.

Here, she moves from the poetic and the fun towards the documentary. With *The Day after Valentine*, she enters myth and legend;

a pagoda's roof resembling a boat suits the tradition that on that day seven girls come down from heaven and one falls for a farmer and stays behind while the others fly off on the horns of an ox. Scarlett made identical dresses for the girls and asked them to let their long, uncut hair hang down – cutting is not a local practice. The resulting scenes have an unusually sinister, gothic atmosphere different from her other work and based in a green landscape. The other girls dress in white for the mourning of their long manes of hair which is cut only three times in their life. It is used as a fabric in surreal portraits playing with traditional ceremonies.

The most recent series, *Red Windmill*, the first constructed in Holland and the most ambitious and mature, is a production on an unprecedented scale. 'I was inspired by Mondrian's early landscape paintings, abstracts and squares and planned to set it in the Dutch landscape because I wanted to insert one square of red into the scene, like in an Old Masters' landscape.'

'In a way, the idea is still very much the same as with the other projects; I always add something – it's the same intervention in the landscape. This time, it's red rope. It took me a few years to plan, and a whole day to build and to take down, one skein at a time.'

Seven people including the millers worked on the active windmill, winding 6,000 metres of strong red nylon rope used for big ships, around the four blades. 'This really has to do with the wind. When I was thinking about Holland and the Dutch landscapes, I was thinking about the wind. In the video, you see it slowly moving.' In the aerial shot from a plane, the wing perfectly frames the scene of a landscape resembling a flat abstract painting. The glowing red diamond, a cat's cradle of rope, is probably visible from the moon. Mondrian had entered the landscape.

As these photographs reveal, Scarlett Hooft Graafland is a fine-art photographer who re-defines documentary. The images in this book are undeniably beautiful, but they also carry her concern for the vanishing worlds whose populations are losing skills, customs and traditions and whose landscapes are being destroyed and transformed. Her photographs will be a valuable archive of what life and land-scapes once were like – with some perplexing intrusions.

Sue Steward

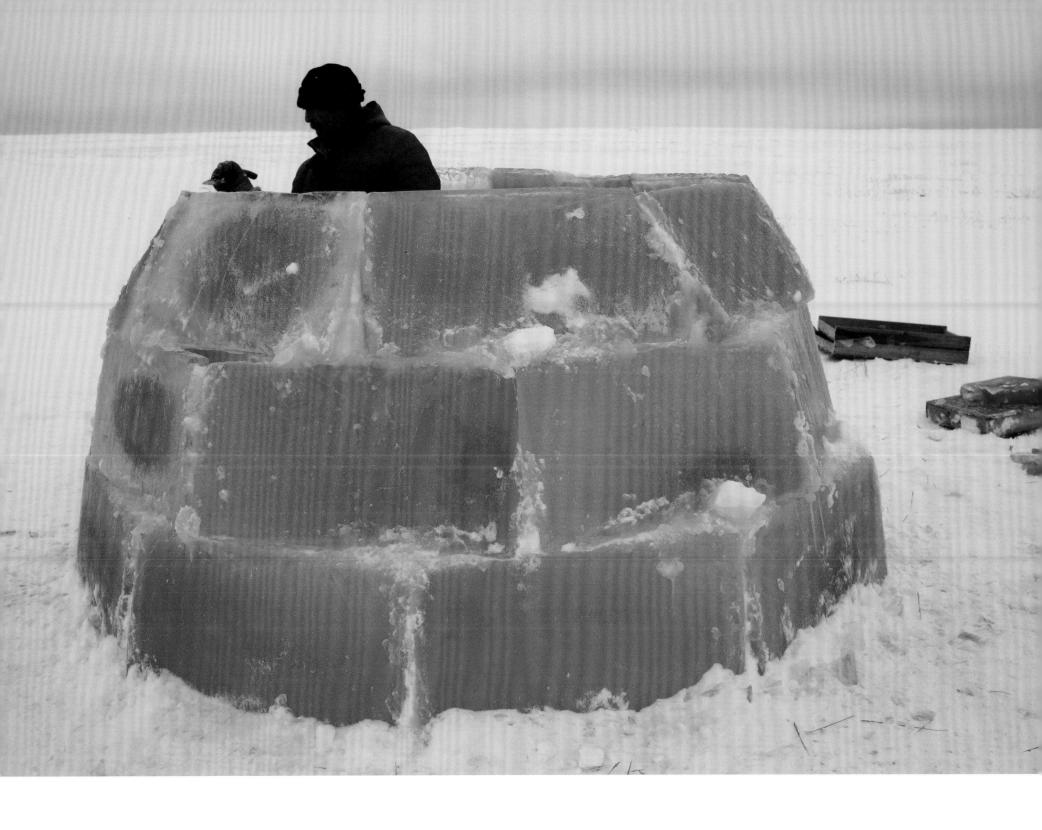

Building a lemonade igloo

Enchanting
the world
with lemonade

If there's one thing you can say about magic, it's that it usually only lasts for a moment: now you see it, now you don't. The same could be said of Scarlett Hooft Graafland's landscape installations. They are, by definition, temporary. The pigment washes away, the balls bounce out of sight, the reindeer thunder into the distance, the men and women turn for home and the balloons drift away. But the images they leave behind are unforgettable. Scarlett Hooft Graafland does not manipulate nature; she interacts with it. In the high plateau of the Bolivian Andes, in the 12,000 km² Salar de Uyuni salt desert, she fills the naturally-formed spaces between the raised edges of the white craquelure with coloured spices, pigments or pieces of kitchen linoleum – and an imaginary carpet appears. She works with nature's own machinations, such as mirroring, floating, hovering, freezing and a sometimes blinding whiteness. Her work is characteristically that of a contemporary artist who uses the world itself as a working space, a type that Nicolas Bourriaud has termed a 'radicant': someone elaborating a 'nomadic type of thought', 'organised in terms of circuits and experiments rather than in terms of permanent installations, perpetuation, and built development.'[1]

This approach is very different from that of past artists who have used landscape as a starting point for their work, such as Robert Smithson and Michael Heizer, the prominent Land artists who created large-scale artworks in nature in the late 1960s and early 1970s, projects which involved huge alterations to the landscape itself. For *Double Negative* (1969), Michael Heizer excavated 240,000 tons of earth in Nevada's Mojave desert to create two enormous mirror-image trenches on either side of a canyon. Robert Smithson dumped 7,000 tons of rock and earth into Utah's Great Salt Lake in order to make *Spiral Jetty* (1970), a 500m pier in the form of a spiral, which had all but washed away after only two years because of the lake's water movements.[2]

Spiral Jetty has become an iconic image that most people know only from photographs. 'Images of the *Spiral Jetty* were in the back of my mind,' says Scarlett Hooft Graafland, talking about the time she spent studying sculpture at Parsons in New York: 'The New Jersey turnpike is not far from New York, and while I was living there I felt a strong involvement with that work. To me the way those Land art artists worked, including Gordon Matta Clark, represents the fundamentals of sculpture. The large-scale approach is very American. There is so much space there; during the seventies the artists used nature as if it were inexhaustible. You could put your mark anywhere. That would not be possible today. I don't want to burden nature with the materials I use. The weather balloons dissolve with time. The title *Vanishing Traces* leaves little doubt about that, I'd say.'[3]

Vanishing Traces (2006) is a work by Scarlett Hooft Graafland that refers directly to *Spiral Jetty*. The installation was created in a Bolivian salt lake, a location which had once also been approved by Robert Smithson himself. The spirit of Smithson haunts this image, and a couple of cryptic sentences from one of his essays inspired the artist. For example: 'It is by this three-dimensional metaphor that one site can represent another site which does not resemble it – thus the non-site.' Smithson's artwork *Spiral Jetty* is gradually becoming a sort of 'non-site' because nature itself is allowing his original artwork to sink – it is literally being engulfed by the Great Salt Lake. In comparison, the sixty two weather balloons that Scarlett Hooft Graafland used to make *Vanishing Traces* have since perished without a trace; the artwork has disappeared, and the 'site' remains exactly what it had always been. For both works, it is the images alone which remain, and Hooft Graafland's images are just as unforgettable as those which remain of the work of her illustrious predecessor.

Quick spirits and brilliant colours

Landscape is indisputably a starting point for Scarlett Hooft Graafland's work. Her photographs are of immense, magnificent landscapes, like the vast Salar desert in Bolivia, bleached white under the scorching sun. Or an Arctic plain in Canada, so cold that even the surrounding sea starts to freeze solid. Or a salt lake in the Andes with a mirror surface that could be water, ice, salt, air or perhaps something even as immaterial as a mirage. These are the *Soft Horizons*. The endless white of Bolivian salt lakes and Arctic plains form the background to many of Scarlett Hooft Graafland's most succinct images. Drained of all colour, these white surfaces can absorb or strongly emphasise, any other hue. The colourful installations that Hooft Graafland adds to these ice fields and salt lakes, such as a pair of bright yellow washing-up gloves, a palm tree made of blood-red seal intestines, a hulk made of acid-green inflatable boats or a carpet of brightly coloured spices, are shocking precisely because they are so conspicuously visible and so short-lived. They are the vivid glimpse of a momentary appearance captured by the photographer. 'That they go together,' writes Michael Taussig, 'quick spirits and brilliant colours, should not be lost on us.'[4]

Colour has always played an essential part in Hooft Graafland's work. 'Benjamin, Proust and Burroughs bring out the fact,' writes Michael Taussig, 'that even in the West colour is a whole lot more than a hue, colour is not secondary to form, that colour is an animal and a magical polymorphous substance as well.' [5] The striking use of colour runs through all Hooft Graafland's images, and it can take a variety of forms. The objects in her installations are everyday materials that one can buy anywhere in the world – nets, rope, rubber gloves, lemonade – but their intense colours lend them a particular significance against these vast, panoramic backgrounds. Take, for instance, the herd of reindeer thundering

past the coloured balls suspended on a fishing line in *March with many Dots* (2009). Or the coloured balls in the foreground of *Pentagon* (2006), floating through the air against a background of mighty grey mountains and a deep blue firmament decked with cumulus clouds. One red and four yellow balls have been tossed into the picture from outside the frame by some young boys; ordinary coloured balls, whose airy flight was captured at the perfect moment by Hooft Graafland's lens. 'Colour itself walks,' writes Taussig. 'What is invisible in one context becomes visible in another.'[6] It is not so much the form or the material but these splashes of colour which give the images their magic. They are artificial colours which would have attracted no notice in their own 'natural' habitats, such as a shop full of plastic home care products. 'In the arcades clashing colours are possible,' wrote Walter Benjamin of nineteenth-century Paris; 'that combs are red and green is not surprising, surprises no one. Snow White's stepmother had such things. And when the comb did not do its work, the beautiful apple was there to help out – half red, half poison-green – like cheap combs.'[7]

Scarlett Hooft Graafland captures the fluid, magical attributes of colour which everyone recognises but no one can name. At the same time, she also paints with the existing colours of the landscape as she finds them. In 2004, inspired by the novel *Independent People* by the Icelandic Nobel laureate Halldór Laxness, she went to Iceland and draped herself, naked, over the colourful roofs of the houses in the middle of a lava field. 'To strengthen the image of a little house in a lava field, I thought it would be good to have two legs in the picture. I'm trying to do something disorienting. And I look carefully at the colours. For instance, in the combination of those black lava beaches and the really green moss. In Reykjavik the roofs are painted all different colours, so that was very special. It gave me a reason to do something

with those roofs, with all those colours in the landscape,' she explains.[8] She is not so interested in the 'authentic' aspects of Icelandic colours, 'derived from the color spectrum that seems to me the most striking in the creation of this nation through the ages,' as Iceland's most prolific artist Birgir Andrésson described in his book *Nearness Colors* (1990).[9] Draped naked over the roof ridge, she is freed of all roots. In combination with the coloured roofs her legs form a sculpture. 'Radicant artists invent pathways among signs,' writes Nicolas Bourriaud. 'They are semionauts who set forms in motion, using them to generate journeys by which they elaborate themselves as subjects even as the corpus of their work takes shape. They carve out fragments of signification, gathering samples and creating herbaria of forms.'[10] In this way, domestic roof ridges, lava beaches, green moss, bare legs and national colours become part of Hooft Graafland's 'iconography of mobility'.[11]

True radicality

This mobility also means that Scarlett Hooft Graafland roots around in all sorts of different cultures, in some of the most diverse places in the world. Her interest lies with the people who live in remarkable places and who often defy extreme conditions. For months at a stretch she integrates completely into their culture, often suffering considerable hardships as a result. 'For there can be no true radicality without an urgent desire for a new beginning, nor without a gesture of purification that assumes the status of a program,' writes Bourriaud.[12] Scarlett Hooft Graafland's radicalism lies not so much in the visible, formal aspects of her art as in the extraordinary lengths she frequently goes to create a work, and in the way she herself becomes a part of the cultures that form the subject of her work. For weeks she travelled with the Inuit across the sea ice of Igloolik, where there was something to eat only if a seal had been caught and killed that day. On one occasion she

almost died when a boat she was sharing with two seal hunters drifted astray. Due to mist and a sudden turn in the weather – the result of climate change – the Eskimos lost their sense of direction. This dramatic event brought her even closer to the Inuit population, and inspired her iconic *Polar Bear*, a work about global warming. 'The polar bear is an animal that is finding it increasingly difficult to survive. The bear had been shot by a female hunter, who let me borrow the skin for the photograph. You can see my bare legs, which could freeze at any moment. To me, this photo is an icon of vulnerability. The intense experience I had when we drifted astray will always remain a gauge for my life.'[13]

She has lived with the locals in places all over the world. 'My most unique experience was the weeks when I was a guest with a potter family on a remote mountain [in the Fujian province of China]. Having breakfast with the family at six-thirty in the morning was an adventure because you witnessed how the members of such a family treat each other and how they are satisfied with the limited, scarce meals of fat and a kind of grass.'[14] The local peculiarities often make her ill, but 'you have to expect that. I travel a lot with a Bolivian artist, Gastón Ugalde, a friend of mine,' she says, 'and we work on all sorts of things together with his assistants, and the locals put us up. They are often very poor people.'[15]

Exchanging rather than imposing

The first performance Scarlett Hooft Graafland captured, with a Hasselblad camera operated by a woman she had met by chance, was in Iceland: 'I had made little drawings of the idea and I showed them to a photographer; she spoke almost no English but she liked the idea. I drew the compositions and she took the photos.'

'After that I bought a Mamiya 7 II, a medium-format camera. Not too heavy and easy to use, because it all has to fit into a backpack. You're not flexible enough with those great

big cameras; I often have to work really fast, especially if the models are local people and communicating with them is difficult. In 2009 Michael Hoppen, my gallery owner in London, lent me his antique panoramic camera, a Tomiyama 7 × 28. It's a very special camera because it uses an extremely wide panorama, a format that is no longer made. I use analogue film and I print straight from the negative. It sometimes looks like I've been using Photoshop, because the images look unnatural, but that's one of the things about my work: everything you see is absolutely real. And I only use natural light.'[16]

Others have called her work 'magical' or even 'surreal', but Scarlett Hooft Graafland prefers to regard her own work as 'engaged' and 'playful'.[17] Using a handful of carefully selected props, she makes small interventions in the landscape and then photographs them. The installation is temporary by definition, and the photo takes over the 'aura' of the original artwork. It is telling that in a digital age Hooft Graafland chooses to use analogue photography; as if the unique, once-only presence of the artwork (the installation or performance) is ideally captured by a single exposure to photographic film. It is almost impossible not to think of Walter Benjamin, whose 1935 essay *The Work of Art in the Age of Mechanical Reproduction* defined the aura of an artwork as the 'here and now', that is: 'its unique existence at the place where it happens to be.' As Bourriaud describes: 'With the technological reproduction of images, he explains, this notion of authenticity is shattered, but not only in the sphere of art: the new modes of production of the image imply both new relations of work and a redefinition of the subject.' […] Benjamin drew from this the surprising conclusion that 'the distinction between author and public is about to lose its basic character. The difference becomes merely functional; it may vary from case to case.'[18]

Seventy-five years after Benjamin wrote these words, Scarlett Hooft Graafland's photographs are a striking depiction of the new relationship between the photographer and her subject in an 'altermodern' age[19] in which signs, stories and cultures intermingle, the artist moves in a nomadic way, and her work perhaps depicts 'what would be the first truly worldwide culture'[20] in a manner that 'exchanges' rather than 'imposes'.

'There comes a moment when you realise just how bad things are for the Aymara women in Bolivia,' says Hooft Graafland, for example. 'That's why I put them on a sort of pedestal: sitting on little mountains of salt, holding candy floss. With pretty names, like "sweetheart" – sweet and salt together.' This was an idea that had come to her while she was living in their community: 'Such a hard life … I wanted to do something with it, and I thought this was a nice gesture.'[21]

She depicts her engagement in a narrative manner. Everyday objects, such as a broom or a candy floss, are given new roles in the tableaux that link the lives of local people with Hooft Graafland's imagination. At the same time, these simple objects are imbued with an almost magical power, perhaps caused by the tangible presence of the stories and cultures of the communities which Hooft Graafland is temporarily exploring. For instance, her Bolivian photographs have an affinity with the Latin American magical realism found in the novels of Gabriel García Márquez who, it is said, was inspired by his aunts, who told fantastic tales as if they had actually happened. At Hooft Graafland's request, the Bolivian women sit atop the salt piles holding up a large, pink candy floss. Elsewhere, on Potosí, a group of Bolivian miners squat in a circle, arms linked by silver inflatable rings. Together they make up the links of an imaginary ornamental chain lying on a 'velvet' bed of grass, their silver mine mountain brooding in the distant background. At her request, Chinese women let their long black hair fall over a horse's back to create a two-tone mane, or sat astride their steep-sided roofs: 'In Fujian there are still a lot of classical roofs. They reminded me of boats. Thinking of my Iceland series, I wanted to place girls on a roof like that, making it seem as if they could paddle away at any moment.'[22] Chinese folk religion involves the worship of various figures from mythology, with creatures such as the Chinese dragon and ancestors. So why, indeed, should these women not suddenly paddle away on their roof-boat? *Polar Bear* is half human, half animal: 'I was able to give that image several layers. It has something very dramatic about it, with that grey light, the bear all huddled up – it looks a bit like Rodin's *Thinker*, but then the legs sticking out make it a rather uneasy image after all … and Inuit sculptures and drawings are often part-human and part-animal. You see the same thing in their myths and legends.'[23]

Many of Scarlett Hooft Graafland's installations, performances and photographs could not have been made without the cooperation of the local population. For *Polar Bear*, for instance, Hooft Graafland scouted for locations accompanied by Sheba Awa, her Inuit assistant. Sheba was a great-granddaughter of the famous shaman Awa.[24] On the snowmobile that Sheba's husband had lent them, the two women travelled for several days looking for the perfect spot, the perfect light, the perfect grey sky. After each photo, the Inuit girl quickly put warm caribou-skin boots back onto Hooft Graafland's feet. 'And when I first saw the results, I was so pleased!' Hooft Graafland relates. 'I had said to Sheba: make sure the head is right on that horizon. Of course, I had no idea what she'd actually do. The fact that it came out exactly how I wanted … we had a digital camera to do try-outs with, but it was so cold that the thing just stopped working. It was terribly cold. I had focused the camera on the tripod, but you never know. And it came out perfectly.'[25]

'Magicienne de la Terre'

Scarlett Hooft Graafland's remarkable images are characterised by a combination of lightness and weight. Her camera infallibly records the moment when nature, installation, colour, engagement, culture and circumstance seem to flow together and form a single, new, magical unity. However playful these photographs may appear, the result is always impressive.

Her work is rooted in an amalgam of Western traditions: from the sculptural works of Smithson and Heizer, and the surrealism of René Magritte – clearly referenced in *Harvest Time* – to the Old Dutch Masters of the seventeenth century, as in *Red Windmill*. At the same time, her work is linked in all sorts of ways to new traditions, other cultures, remarkable locations and fascinating people. It has formed a nomadic oeuvre that is intercultural while also manifesting a strong sense of unity. Its landscape intervention may be temporary but its engagement with the world is long-term. Scarlett Hooft Graafland is a 'Magicienne de la Terre' of the twenty-first century: someone who can dye an igloo with lemonade. It is precisely this unique combination of factors which mark her out as a contemporary, 'radicant artist', whose works move us, amuse us surprise us, and set us thinking.

Huis Marseille is honoured to host the first retrospective of Scarlett Hooft Graafland's work. It was not only Amsterdam, after all, from which this fascinating imagery first emerged and where the many adventures which ultimately led to these photographs first began but also New York. Today, Scarlett Hooft Graafland is a global citizen. After many small-scale solo exhibitions and inclusion in numerous group exhibitions all over the world, Huis Marseille is the first place to bring everything under one roof. A museum is one of the few places where time can be made to stand still and magic allowed to come to life. There is nothing more to wish for in these imagined landscapes but that every person who helped her to create these works could come too. To see themselves in these otherwise harsh landscapes – when they were briefly part of a humorous but dreamlike world – the world according to Scarlett Hooft Graafland. If only for a moment.

Els Barents and Nanda van den Berg

1 Nicolas Bourriaud, *The Radicant*, New York, 2010 (originally published in 2009), p. 53.

2 Kitty Zijlmans, 'Geënsceneerde natuurbeleving: land art in Nederland' in: Jan Kolen & Ton Lemaire (eds.), *Landschap in meervoud. Perspectieven op het Nederlandse landschap in de 20ste/21ste eeuw*. Utrecht, 1999, p. 435.

3 Scarlett Hooft Graafland in conversation with Tineke Reijnders in: *Discovery*, Vous Etes Ici Gallery:. Amsterdam, 2008 (unpaginated)

4 Michael Taussig, *What Color is the Sacred?* University of Chicago Press, 2009, p. 5.

5 *Idem*, p. 31.

6 *Idem*, p. 38.

7 Quoted in Taussig, *idem*, p. 36.

8 Scarlett Hooft Graafland in an interview with Nanda van den Berg. Conversation recorded on 10 June 2011 in Amsterdam. www.huismarseille.nl

9 Quoted in the thesis of Aline Grippi, 'Josef Alberts & Birgir Andrésson: Influences of Environment on Color Perception,' 2011. http://skemman.is//sgtream/get/1946/8743/23706/1/Lokaritgerd.pfd

10 Bourriaud, *op. cit.* (footnote 1), p. 53.

11 *Idem*, p. 7.

12 *Idem*, p. 46.

13 Conversation with Tineke Reijnders, *op. cit.* (footnote 3).

14 *Idem*.

15 Conversation with Nanda van den Berg, *op. cit.* (footnote 8).

16 *Idem*.

17 *Ibidem*.

18 Quoted in Bourriaud, *op. cit.* (footnote 1), p. 41.

19 A term coined by Bourriaud: the age after postmodernism.

20 Bourriaud, *op. cit.* (footnote 1), p. 17.

21 Conversation with Nanda van den Berg, *op. cit.* (footnote 8).

22 Conversation with Tineke Reijnders, *op. cit.* (footnote 3).

23 Conversation with Nanda van den Berg, *op. cit.* (footnote 8).

24 Shaman Awa is a well-known name in the area; he had conversed with the explorer Knut Rasmussen.

25 Conversation with Nanda van den Berg, *op. cit.* (footnote 8).

The artist wishes to thank

Huis Marseille: Els Barents, Nanda van den Berg,
Caroline de Pont; Aap-lab: Peter Svenson;
Souverein: Ad Degen, Paul Brugman;
Kehrer Verlag: Klaus Kehrer, Ariane Braun,
Alexa Becker; Francis Boeske, Hans Gieles,
Bart de Haas, Jacqueline Hassink,
Annekee Hooft Graafland-van Vliet,
Folef Hooft Graafland, Gilles Hooft Graafland,
Michael Hoppen, Sabrina Kamstra, Tristan Lund,
Charlotte Nation, Meiti van Nieuwenhuizen-
Vergouwen, Manja Otten, Tineke Reijnders,
Sue Steward, Clarisse Venekamp

Thanks also go to everyone who helped realise
all of these projects all over the world, especially
– Bolivia; Gastón Ugalde, Masmo Huallpa,
 Carlos Gonzales, Marco Castro,
 Rosendo Barco, Sammy Blanco, Pasqual,
 Alain-Paul Mallard, Edgar Arandia Q.,
 Eran Nagan, Mariano Ugalde
– Holland (windmill Gorinchem): Jeroen Thomas,
 Menno Derk Doornbos,
 Stichting Molen 'de Hoop', Herman Sangers,
 Frans Klijn, Jenne Sipman, Stefan Kuit,
 Liedeke Kruk, Wiebo van Mulligen,
 Robin van Eijk, Anneke A. de Boer,
 Guido Marsille
– India: Minijit Singh, Sodni Singh
– Norway: Hans-Jørgen Wallin Weihe,
 Silvy Gunderson, Kenneth Jakobsson
– Canada, Igloolik: Sheba Awa, Georgia, Pacome
 and Aida Qulaut, Paul Qassa, Nathan Qamaniq,
 Sonia Gunderson, Paul Irngaut, Wim Rasing,
 John MacDonald, Mary Airuk
– China: CEAC, Ineke Gudmundsson,
 Sigurdur Gudmundsson, Li Wen, Shuang Fa,
 Jin Se, Rodney Cone, Stevens Vaughn,
 Courtney Cone, Eastlink Gallery, Li Liang
– Iceland: Marisa Navarro Arason,
 Ingibjörg Gunnlaugsdóttir,
 Hekla Dogg Jonsdottir

Galaxy 1 satellite communication, Florida

The Netherlands Foundation for
Visual Arts, Design and Architecture

KRUG
Special thanks to Krug champagne

Colophon

This book is published in conjunction with
the exhibition
Scarlett Hooft Graafland, Soft Horizons
Huis Marseille, Museum for Photography,
Amsterdam
10 September – 20 November, 2011
www.huismarseille.nl

Sue Steward is a writer, broadcaster,
photo editor and reviewer of photography for
BBC radio's Arts Magazine and World Music
programmes

Els Barents is the director of Huis Marseille,
Museum for Photography, Amsterdam

Nanda van den Berg is senior curator of
Huis Marseille, Museum for Photography,
Amsterdam

Translation pp. 118–121: Ralph de Rijke
Graphic design: Bart de Haas, The Hague
Reproductions: Souverein Weesp B.V.
Proofreading: Wendy Brouwer
Production: Kehrer Design Heidelberg
(Thomas Streicher and Marijke Domscheit)
Image processing: Kehrer Design Heidelberg
(Jürgen Hofmann, René Henoch)
Paper: Multi Art Matt 170 g/m²
Printing: Engelhardt und Bauer, Karlsruhe
Binding: Joseph Spinner Großbuchbinderei,
Ottersweier

Cover illustration: *Polar Bear*

ISBN 978-3-86828-223-8

 Kehrer Verlag Heidelberg Berlin
www.kehrerverlag.com